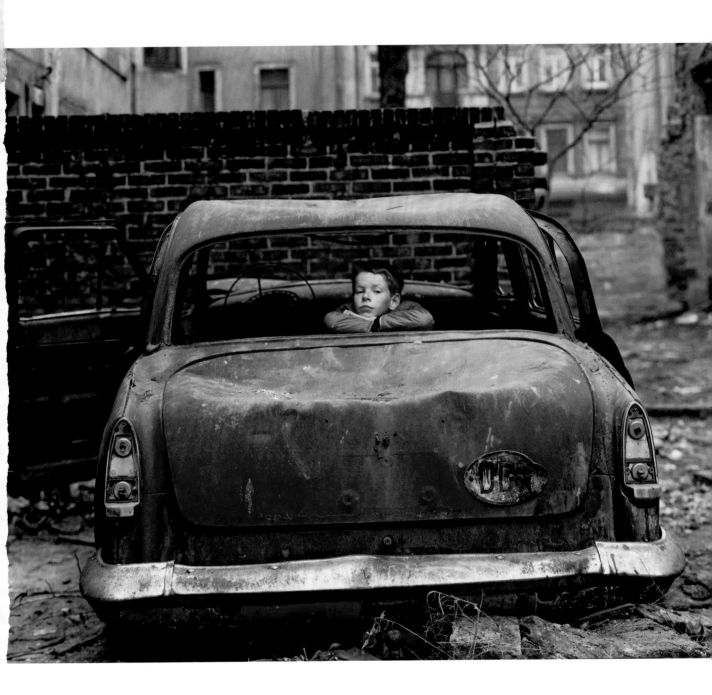

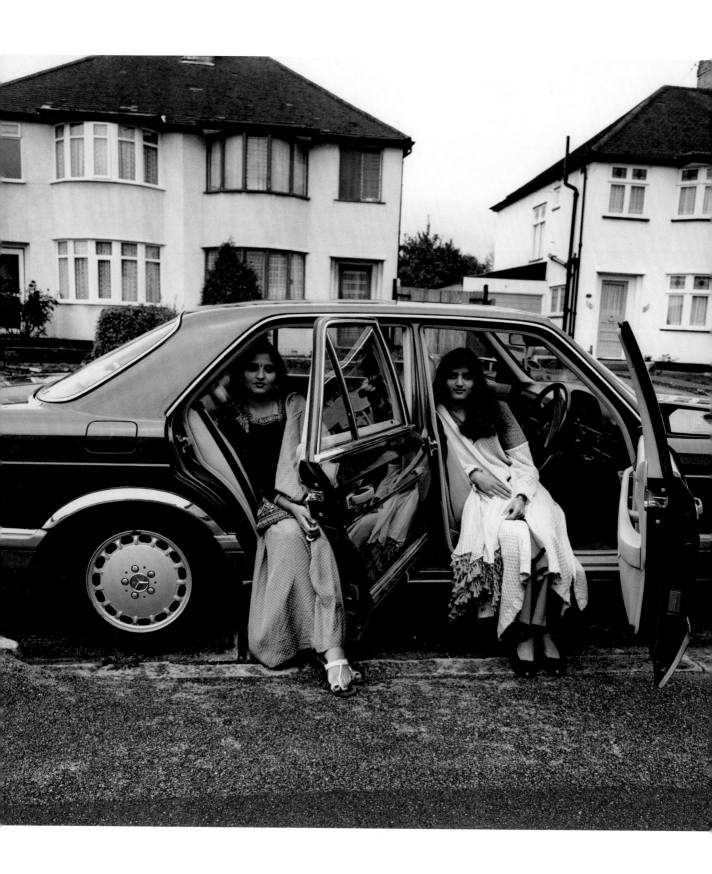

AUTOMANIA

JULIET KINCHIN

**With contributions by
Paul Galloway
Andrew Gardner**

The Museum of Modern Art, New York

Allianz (ⅲ)

Allianz, MoMA's partner for design and innovation, is proud to sponsor *Automania* at The Museum of Modern Art. This groundbreaking exhibition will showcase the Museum's collection of automobiles alongside related objects—including car parts, architectural models, films, photographs, posters, paintings, and sculptures—and will take an in-depth look at an object that has inspired countless examples of innovation, social transformation, and critical debate among designers and artists working in varied media. Since the first automobiles hit the road over a century ago, cars have left a lasting imprint on the design of our built environment. They have fundamentally reshaped the ways in which we live, work, and engage with one another and the world around us. Cars have redefined the notion of mobility, connecting us across great distances at ever greater speeds. This exhibition also considers the impact that automobiles have had on the natural environment, a testament to the work still to be done. With Allianz being founded on the invention and evolution of cars, the company continues to be deeply committed to advancing innovation and transformation in this space, prioritizing sustainable solutions and business practices as we collectively work toward carbon neutrality and a more sustainable environment, economy, and society.

ABOUT ALLIANZ

The Allianz Group is one of the world's leading insurers and asset managers with more than 100 million retail and corporate customers in more than 70 countries. Allianz customers benefit from a broad range of personal and corporate insurance services, ranging from property, life, and health insurance to assistance services to credit insurance and global business insurance. Allianz is one of the world's largest investors, managing around 766 billion euros on behalf of its insurance customers. Furthermore, our asset managers PIMCO and Allianz Global Investors manage 1.7 trillion euros of third-party assets. Thanks to our systematic integration of ecological and social criteria in our business processes and investment decisions, we hold the leading position for insurers in the Dow Jones Sustainability Index.

FOREWORD

Automobiles are magnificent, maddening machines. No other product of industrial design in the modern era has altered human behavior, society, and the environment as irrevocably as the personal motorcar. The centrality of cars to the story of modernism offered a rich vein from which artists, designers, and architects crafted new ways of experiencing the world around us. Drawing on the ten vehicles and wealth of automobile-related art, architecture, and design in the collection of The Museum of Modern Art, *Automania* takes an in-depth look at an object that inspired countless innovations, social transformations, and critical debates among designers and artists working in varied media.

Although MoMA's commitment to exhibiting industrial design extends back at least to Philip Johnson's *Machine Art* show in 1934, the Museum's engagement with cars began in 1951 with the exhibition *8 Automobiles*—a show in which they were examined as primarily aesthetic objects. Indeed, the curator, Arthur Drexler, famously went so far as to refer to them as "hollow, rolling sculpture." In the years since, MoMA has mounted further exhibitions on car design and the wider impact of the automobile, ranging from retrospective surveys to projects focused on racing cars, road systems, or future directions of car design. *Automania* instead presents a more holistic picture of the impact of cars on the worlds of art and design in the late nineteenth and twentieth centuries, from the ungainly contraptions of the 1890s to the micro-compact gas-saving Smart Car, and marks the return of automobiles to the Abby Aldrich Rockefeller Sculpture Garden for the first time since 1999—a rare treat.

The exhibition takes its name, and ample inspiration, from *Automania 2000*, the 1963 animated short from the pioneering British duo John Halas and Joy Batchelor. The film deftly skewers our obsession with cars and ends with an ominous scene of self-reproducing cars burying the world. At a moment in which the environmental and societal cost of personal cars has the world reconsidering the future of mobility, *Automania* offers an opportunity to look back at how and why our mania for cars began. These beautiful, powerfully seductive machines are well deserving of close examination, study, and a sharply critical eye.

Organized by the Department of Architecture and Design, with Juliet Kinchin joined by Paul Galloway and Andrew Gardner, the exhibition draws on materials from all curatorial departments at the Museum, and its focus on the environmental implications of car culture resonates with the institution's urgent initiative to reduce carbon emissions 30 percent by 2024 and material consumption and waste 50 percent by 2025. I am grateful to the organizers and to their many colleagues throughout MoMA who worked tirelessly to bring this ambitious effort to fruition despite the challenges presented by the COVID-19 pandemic. On behalf of the staff and trustees of the Museum, I offer my deepest thanks to Allianz for making this exhibition possible, and to Kristen and Andrew Shapiro and our Annual Exhibition Fund donors for their generous support.

—GLENN D. LOWRY
The David Rockefeller Director
The Museum of Modern Art

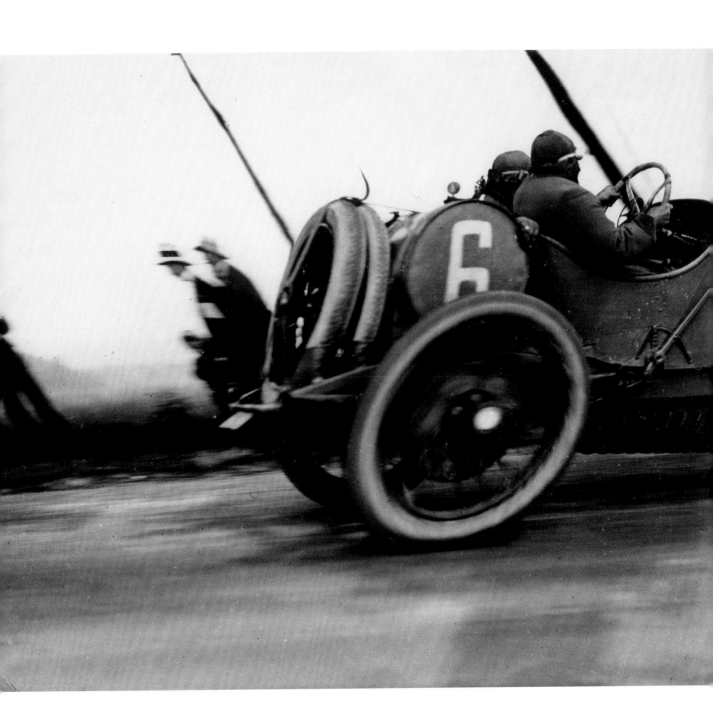

8
automobiles

Leo Lionni (American, born Amsterdam. 1910–1999)
Cover of the catalogue for the exhibition *8 Automobiles*. 1951
Published by The Museum of Modern Art, New York
The Museum of Modern Art Library, New York

INTRODUCTION

"Museum to Open First Exhibition Anywhere of Automobiles Selected for Design," trumpeted a Museum of Modern Art press release in 1951.[1] The fall of that year, MoMA presented *8 Automobiles* (opposite; fig. 1), a show of European and American cars selected for "their excellence as works of art." The designation bewildered the public and journalists alike: "Yer nuts! Automobiles—that screwy art they call modern? You mean I got a hunk of art in my garage?" queried a "Joe Doakes" in one review. "Well, that's right, brother, Automobiles are art," came the response. "And so are your electric toaster and your washing machine and a great many other things you use every day without thinking. . . . It's the art of OUR age, and it's a good thing that there are some institutions waking up to the fact."[2] The *New York Times* critic Aline Louchheim picked up the story in the form of conversation between a "Man from Mars" (M. from M.) and a testy, condescending "Museum Official" (Mus. Off.) trying to explain the automobiles' presence:

Mus. Off.: [. . .] Good Heavens, don't you know automobiles are hollow, rolling sculpture?
M. from M.: Good Earth, they are?
Mus. Off.: They have interior spaces corresponding to an outer form, like buildings. [. . .]

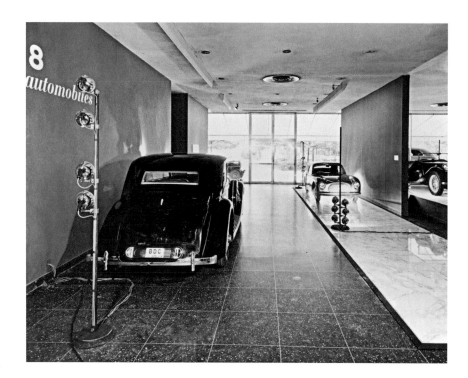

1.
8 Automobiles, The Museum of Modern Art,
New York, August 28–November 11, 1951.
Installation view. MoMA Archives, New York

M. from M.: [. . .] *I thought the most important points about an automobile were the excellence of its motor, its safety factors and the comfort it provides its passengers.*
Mus. Off. (impatiently): Of course, certainly. But that is not our problem. This is an exhibition concerned with the aesthetics of motor car design.
M. from M. (eagerly): You mean, with chromium and that grille on the front which Europeans call "the dollar grin"?
Mus. Off. (shuddering): No, no, certainly not. That is just what we don't mean. [. . .]
M. from M.: [. . .] *Wonder how the public will take to this exhibition. People are touchy about cars.*[3]

Car design certainly was, and still is, an emotive topic about which many people hold forthright views based on personal experience. But with polemical intent, Arthur Drexler—who organized the exhibition with assistance from Philip Johnson, the head of MoMA's Department of Architecture and Design, and John Wheelock Freeman, an outside consultant—used this accessible and ubiquitous industrial product to raise larger questions about what qualified as modern art. In this regard, *8 Automobiles* was in keeping with the vision of the Museum's founding director, Alfred H. Barr, Jr. Before assuming leadership of MoMA, Barr had taught the first modern art course at Wellesley College in Massachusetts. Keen for his students to understand the age in which they lived, he accompanied them not only to art galleries, the cinema, and theaters, but to the National Automobile Show held in New York's Grand Central Palace in 1928. His interdisciplinary approach was carried through to the exhibitions of everyday objects and industrial design held at MoMA from the 1930s—notably *Machine Art* (1934), the Useful Objects series (1938–48), and the Good Design program (1950–55)—which prepared the way for the appearance of the automobile as art.

8 Automobiles was in effect a "car-body show"[4] that put issues of functionality, safety, and technical performance to one side. Two design approaches were highlighted—the envelope (epitomized by the sporty Cisitalia 202 [see

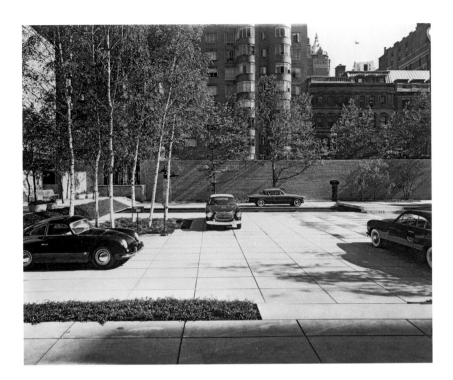

2.
Ten Automobiles, The Museum of Modern Art,
New York, September 15–October 4, 1953.
Installation view. MoMA Archives, New York

pages 58–61]) and the box on wheels (exemplified by the Willys-Overland Jeep [see pages 18–21]). Both cars would in due course be acquired by the Museum for its permanent collection. Undoubtedly the curatorial choices of Drexler, Johnson, and Freeman raised some hackles, and the Museum's apparent European bias in the area of cars has been a topic of lively debate ever since. Johnson described the Cisitalia's body as being slipped over the chassis like a "dust jacket over a book"—clearly a car for the intelligentsia—whereas the Jeep, which combined the "appeal of an intelligent dog and perfect gadget," came from lower down the evolutionary chain.[5]

The "hollow, rolling sculpture" show drew large attendances. It was reprised two years later as *Ten Automobiles* (fig. 2), with a Studebaker Commander V-8 Starliner Coupe among the additions. A refined take on the space-age aesthetic then favored by American automakers, the Studebaker's streamlined form inspired two visitors to speculate on the car's origins: "They're back!" "Where from?" "The moon!"[6] The French critic Roland Barthes also used an extraterrestrial metaphor when he described the Citroën DS 19 that launched at the 1955 Salon de l'Automobile in Paris as having "fallen from the sky."[7] He noted how an awestruck public was mesmerized by the perfect dovetailing of its sections: "One keenly fingers the edges of the windows, one feels along the wide rubber grooves which link the back window to its metal surround." Barthes was in no doubt about the cultural significance of cars, which he considered "almost the exact equivalent of the great Gothic cathedrals: I mean the supreme creation of an era, conceived with passion by unknown artists, and consumed in image if not in usage by a whole population which appropriates them as a purely magical object."[8]

The Museum's acquisition of a Citroën DS in 2018 (see pages 22–25) brought the total number of vehicles in the collection to ten; save for the Jeep, all of MoMA's cars were designed and manufactured in Europe. Yet arguably it was in the US that the automobile was embraced most fully. "Not a phase of American life, not even her humor, has been untouched by the automobile," wrote Clyde L. King, an American professor of political science, in 1924. "The

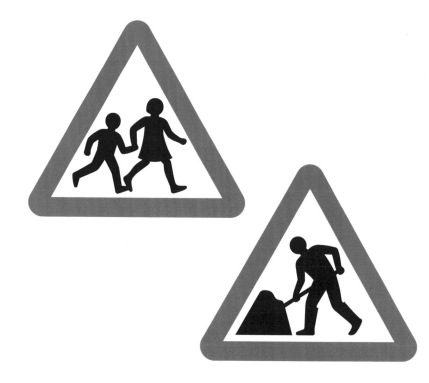

home, the school, the church; recreation, production, distribution; agriculture, advertising, plant location; highway safety, the courts; city planning, public expenditures, international problems—all have felt the driving power of the automobile."[9] European visitors were stunned by the spectacle of Henry Ford's assembly-line production in Detroit and the sheer volume of traffic in American cities. "The whole population drives, races, honks through the cities, over the country roads, for business, for pleasure, for sport, to the cinema, for tête-à-têtes," observed one German visitor in 1926.[10] In the late twentieth century, many artists and designers became increasingly critical of the view articulated by Drexler and Johnson that automobile design should be held to a "timeless" ideal above the vicissitudes of fashion—a standard more often met, it seemed, by European cars. Yet it was to the chrome-laden automobiles pouring out of Detroit that pioneers of British Pop art, such as the artists Richard Hamilton and Eduardo Paolozzi (fig. 3) and the critic Reyner Banham, turned for inspiration from the late 1950s. Cars—and this push-pull relationship between the US and Europe—went to the heart of larger debates around modernism, consumerism, and popular culture, and played a pivotal role in MoMA's articulation of concepts of "good" design at mid-century.

　　Vehicles are costly to store, conserve, and display, and it was never the Museum's intention to form a comprehensive collection. The collection of car-related objects, however, is substantial, which should come as no surprise given the transformative impact of the automobile—for better and for worse—and its position as an icon of modernity throughout the twentieth century. Over the years the Department of Architecture and Design has acquired car accessories and components; posters; street signage (fig. 4) and road maps; and architectural models and drawings that relate to car-centric structures—all offering a lens through which to better understand how the automobile has reshaped our conceptions of space and the built environment. In Louchheim's review of *Ten Automobiles*, the critic noted that although depictions of "the sleek and refined examples which the Museum of Modern Art chooses to consider works of art"

3.
Eduardo Paolozzi (British, 1924–2005)
Untitled, from the portfolio *Moonstrips Empire News*. 1967
One from a portfolio of 101 screenprints (including title page and colophon), comp.: 14 5/16 × 9 5/16 in. (36.4 × 23.6 cm); sheet: 14 15/16 × 9 15/16 in. (38 × 25.2 cm)
Publisher: Editions Alecto, London
Printer: Kelpra Studios Ltd., London
Edition: 500
The Museum of Modern Art, New York. Gift of the artist

4.
Jock Kinneir (British, 1917–1994)
Margaret Calvert (British, born 1936)
Children-crossing and roadwork signs. Originally designed 1957–67, these versions 2021
Retroreflective sign face sheeting, composite substrate, aluminum alloy support channels, each 23 5/8 × 26 3/4 × 1 5/16 in. (60 × 68 × 3.3 cm)
Designed for the Ministry of Transport (now Department for Transport), UK
Manufacturer: Royal British Legion Industries (Aylesford, UK, est. 1919)
The Museum of Modern Art, New York. Committee on Architecture and Design Funds

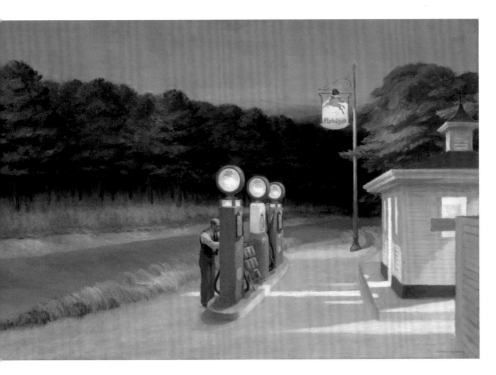

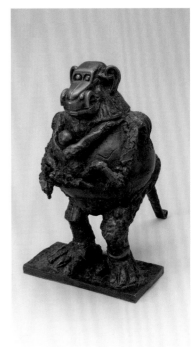

5.
Edward Hopper (American, 1882–1967)
Gas. 1940
Oil on canvas, 26 ¼ × 40 ¼ in. (66.7 × 102.2 cm)
The Museum of Modern Art, New York.
Mrs. Simon Guggenheim Fund

6.
Pablo Picasso (Spanish, 1881–1973)
Baboon and Young. 1951, cast 1955
Bronze, 21 × 13 ¼ × 20 ¾ in. (53.3 × 33.3 × 52.7 cm)
The Museum of Modern Art, New York.
Mrs. Simon Guggenheim Fund

are scarce in the collection of contemporary paintings, "the *implications of the automobile*" had made themselves felt: "More than any other single thing the automobile has changed our common view of the world, accustoming us to 'multiple perspectives,' to deformations of form, to kinetic images, to the fragment. In short, to the vision which has touched all modern art."[11] She could see that the very absence of automobiles in Edward Hopper's *Gas* (1940; fig. 5), with its pumps and attendant isolated at the roadside, reinforced the painting's mood of loneliness, detachment, and bored immobility. Artworks are to be found in every corner of the Museum that reflect, directly or indirectly, on the hold of the automobile over our imaginary and terrestrial lives. As a physical extension of the human body, a sublimated manifestation of our inner emotions, or an expression of social identities inflected by race, class, and gender, the motorcar presents rich territories for artists to explore.

Created in 1951, the year of the *8 Automobiles* exhibition, Pablo Picasso's assemblage *Baboon and Young* alludes to the way cars have suffused the human psyche (fig. 6). To form the baboon's head, Picasso sandwiched together the undersides of two toy cars (appropriated from his son); her eyeballs are framed by a windshield, and her mouth and lips are created out of "dollar grin" radiators. Picasso adapted another car part, a leaf spring terminating in a taut spiral, to form the animal's spine and long tail. These elements, embedded in the baboon-mother's makeup, remain recognizable in the final cast form of the sculpture. She has the totemic presence of some primeval yet modern deity, fusing animal, human, and machine parts. By implication, the essence of automobiles will be transmitted to the human child clinging to her breast.

Aldous Huxley speculated on the ramifications of car idolatry in his futuristic novel *Brave New World* (1932), in which Henry Ford is revered as the creator of a "World State" built on the principles of his assembly line. Citizens, like Ford cars, are mass-produced, homogeneous, and disposable; the regimented, mind-numbing drudgery of the assembly line has turned them into unthinking machines. Fraught labor relations have dogged the automotive industry since

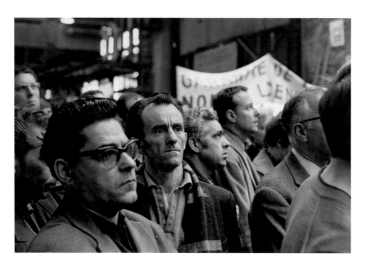

Ford first introduced automated production in the early twentieth century, as captured in Henri Cartier-Bresson's photograph of Renault workers striking in Paris in 1968 (fig. 7). The dystopian vision of *Automania 2000*—the 1963 animated film by the British studio Halas and Batchelor from which this project takes its name—suggests that technological innovation is a double-edged sword: if mass production initially brought about undreamt-of standards of living, it also leads to gridlocked immobility and, ultimately, the extinction of civilization.

Since the beginning of the twentieth century, car-themed toys and entertainment—ranging from Hans Brockhage and Erwin Andra's "rocking car" (1950; fig. 8) to the video game franchise *Grand Theft Auto*—have been consistently popular across age groups. Death-defying car chases in books and film offer further vicarious experiences of driving. One of the most enduring contributions to this canon is Kenneth Grahame's *The Wind in the Willows* (1908), in which the character Mr. Toad is placed under house arrest by concerned friends following a destructive bender behind the wheel. Stubbornly resistant to being cured of his addiction, he reenacts his wild rides using pieces of furniture: "When his violent paroxysms possessed him he would arrange bedroom chairs in rude resemblance of a motor-car and would crouch on the foremost of them, bent forward and staring fixedly ahead, making uncouth and ghastly noises, till the climax was reached, when, turning a complete somersault, he would lie prostrate amidst the ruins of the chairs."[12]

Cars have long functioned as a strategic tool of impression management among family, friends, and fellow citizens. To get on in 1920s America required owning an up-to-date and well-maintained automobile. According to Ise Gropius, "these respectable mechanized pets" were a kind of "calling card" in New York: "One is 'attired' in a Cadillac, a Buick, a Ford! . . . A solid, well situated salesman doesn't drive a Rolls Royce because that would be taken as snobbery, and an advanced individual no longer shows himself in a Ford! The auto has assumed the prestige functions that formerly belonged to the house."[13] This was certainly the case for a well-to-do couple photographed in the Manhattan neighborhood

7.
Henri Cartier-Bresson (French, 1908–2004)
Meeting chez Renault, Paris. 1968
Gelatin silver print, 15 ⅝ × 23 ½ in. (39.7 × 59.7 cm)
The Museum of Modern Art, New York.
Gift of the artist

8.
Hans Brockhage (German, 1925–2009)
Erwin Andra (German, born 1921)
Schaukelwagen (Rocking car). 1950
Beech frame and birch plywood seat,
15 ¾ × 39 ⅜ × 14 ¹⁵⁄₁₆ in. (40 × 100 × 38 cm)
The Museum of Modern Art, New York.
Architecture & Design Purchase Fund

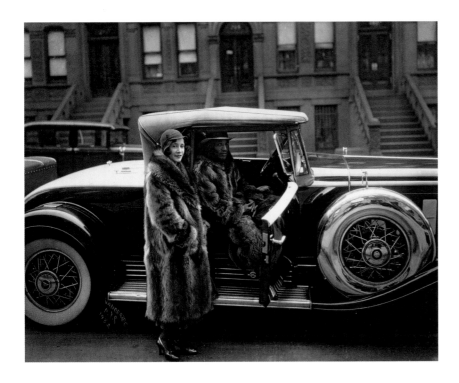

of Harlem in 1932 (fig. 9), then in the midst of the Harlem Renaissance. The photographer, James Van Der Zee, was a leading figure of this movement. Swathed in his-and-hers raccoon coats, the couple exude majesty, but the real star of the portrait is the gleaming Cadillac V-16—a top-of-the-range luxury model styled by Harley Earl—with which they are posed. About four thousand of these cars were made in the 1930s, each with a customized chassis. The Depression was biting deep, so powering a car with sixteen cylinders at a time when fours and sixes were the norm immediately signaled wealth and exclusivity. For the pair in Van Der Zee's photograph, this display of status would have had an added layer of meaning during a time when Black Americans faced discrimination in so many other areas of cultural expression.

A Mercedes in the portrait of twins Shilpa and Sheetal Patel, taken six decades later by Ketaki Sheth in the London borough of Harrow, similarly reflects the particular import that car ownership as a means of upward social mobility has in minority communities (see frontispiece, page 2). Empowered by the possession of their own mobile space, the sisters—whose family had built up a successful auto parts business—are pictured outside the suburban home of their grandmother, who was among tens of thousands of South Asians expelled from Uganda by President Idi Amin in 1972. Newly arrived in the United Kingdom from Mumbai, Sheth was in the process of examining her own place within the Indian diaspora, and the sisters were one of many subjects she photographed for a project that was later published as *Twinspotting: Patel Twins in Britain and India* (1999).

In addition to making suburban living possible, cars opened up the countryside to mass leisure. "Everywhere You Go You Can Be Sure of Shell" was a 1930s advertising campaign through which Shell targeted an expanding group of middle-class British motorists, commissioning named artists to create posters for beauty spots like Gordale Scar in England's Yorkshire Dales (fig. 10). The damage wrought on natural landscapes by the construction of roads and filling stations and by invasive oil extraction was far from universally welcome. By presenting visions of the British countryside removed from disfiguring industry,

9.
James Van Der Zee (American, 1886–1983)
Couple in Raccoon Coats. 1932
Gelatin silver print, 7 ½ × 9 ⁵⁄₁₆ in. (19 × 23.7 cm)
The Museum of Modern Art, New York.
Acquired through the generosity of Richard E. and Laura Salomon

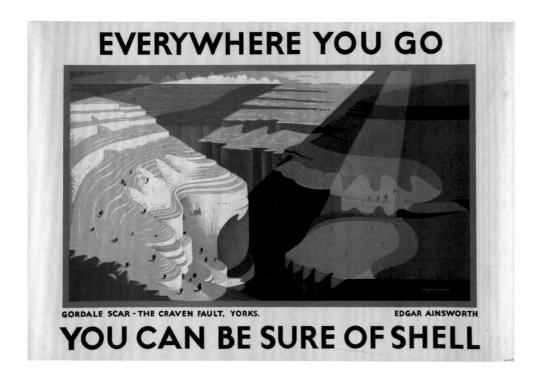

EVERYWHERE YOU GO

GORDALE SCAR - THE CRAVEN FAULT, YORKS. EDGAR AINSWORTH

YOU CAN BE SURE OF SHELL

Shell sought to divert attention from its association with environmental harm. Shell's use of artists to soften its public image was an early form of artwashing, a by now well-established branding strategy practiced by the polluting fossil fuel industry—exposed by the German Conceptual artist Hans Haacke's critique of Mobil Oil's art patronage in the 1970s and 1980s and more recently by the climate-activist group Extinction Rebellion's ongoing protests against BP's sponsorship of the National Portrait Gallery in London.

 The aesthetics of infrastructure was the subject of *Roads* (1961), a MoMA circulating exhibition of aerial photographs. Viewed from above, the visually complex traffic circles, clover leaf intersections, and multilevel interchanges of urban traffic arteries read as abstract works of art (fig. 11). The ground-level vision from inside a car offers a kind of experience more akin to the insistent temporal flow of music and cinema. The electronic band Kraftwerk experimented with the hypnotic rhythms of driving along West German motorways in their signature album *Autobahn* (1974; fig. 12). The album features car sounds band member Ralf Hütter captured by hanging a tape recorder out the window of his gray Volkswagen (visible on the album cover) while traveling from Cologne to Bonn: "Adjusting the suspension and tyre pressure, rolling on the asphalt, that gliding sound—pffft pffft—when the wheels go onto those painted stripes. It's sound poetry."[14] While *Autobahn* can be seen, in part, as a celebration of West German engineering, the burned-out Trabant in Eberhard Grames's photo *Boy in a Wrecked Car, Dresden* (1989; see page 1) might be read as symbolic of the former East Germany and of the collapse of the Eastern Bloc in general.

 From plaything of the rich to utilitarian necessity of modern life to artistic muse, the car has triggered conflicting responses since its first appearance in the 1890s. Some have viewed the car as the ultimate expression of technological progress, capable of bringing about positive societal change, while others have seen it as the enemy of humanistic values, leading only to destruction. Current efforts to render the combustion engine redundant suggest we have reached a critical moment in this narrative. Robot-controlled cars promise cleaner air.

10.
Edgar Ainsworth (British, 1906–1975)
Everywhere You Go You Can Be Sure of Shell. Gordale Scar—The Craven Fault, Yorks. 1934
Lithograph, 30 × 45 in. (76.2 × 114.3 cm)
The Museum of Modern Art, New York.
Gift of Shell-Mex BP

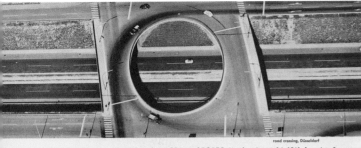

road crossing, Düsseldorf

e Museum of Modern Art invites you to the preview of an exhibition of **ROADS**, Monday, August 14, 1961, from 6 to 8 p.m.
West 53 Street, New York. The exhibition will be on view until September 17. Please present this invitation.

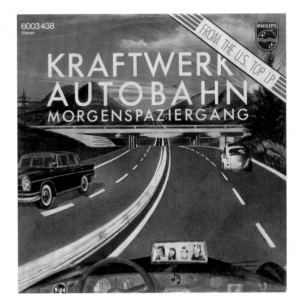

Fewer young people are learning to drive, and fewer still are able to repair cars, including the electric models that are becoming increasingly prevalent. Escalating environmental concerns, combined with the restricted mobility and economic crisis engendered by the COVID-19 pandemic, are focusing public attention on the urgent need for creative strategies and government action to shape the future of personal transportation. New directions will require clear-eyed reflection on why cars have been, and continue to be, so important to us. For all their ubiquity and attendant problems, these everyday objects still have the power to enthrall as works of art—if only as museum pieces.

11.
Aerial photograph of a Düsseldorf road crossing on the invitation to a preview of *Roads*, The Museum of Modern Art, New York, August 14–September 17, 1961. MoMA Archives, New York

12.
Kraftwerk (Germany, est. 1970)
Cover for the album *Autobahn*. 1974
Lithograph, 7 ¼ × 7 ⅜ in. (18.4 × 18.7 cm)
The Museum of Modern Art, New York. General Print Fund

1 The Museum of Modern Art, New York, "Museum to Open First Exhibition Anywhere of Automobiles Selected for Design," press release no. 510823-46, August 23, 1951.
2 Press clipping, "Modern Art in Your Garage," September 6, 1951, MoMA Archives, The Museum of Modern Art Exhibition Records (MoMA Exhs.).
3 Aline B. Louchheim, "Automobiles as Art," *New York Times*, September 2, 1951.
4 John Wheelock Freeman, "What Is Good Design?" *Auto Sport Review*, July 1952, 50.
5 Philip Johnson, quoted in Bert Pierce, "Auto as Art Work Is Museum Exhibit," *New York Times*, August 29, 1951.
6 A conversation between two college classmates overheard by Thomas S. Hines, quoted in Hines, *Architecture and Design at the Museum of Modern Art: The Arthur Drexler Years, 1951–1986* (Los Angeles: Getty Research Institute, 2019), 48.
7 Roland Barthes, "The New Citroën," in *Mythologies*, trans. Annette Lavers (New York: Hill and Wang, 1972), 88.
8 Ibid.
9 Clyde L. King, foreword to *Annals of the American Academy of Political and Social Science* 116, no. 1 (November 1924): vii.
10 Paul Rohrbach, quoted in *Walter Gropius: American Journey 1928*, exh. cat., ed. Gerda Breuer and Annemarie Jaeggi (Berlin: Bauhaus-Archiv, 2008), 29.
11 Louchheim, "The Automobile in Modern Art," *New York Times*, September 20, 1953.
12 Kenneth Grahame, *The Wind in the Willows* (London: Methuen, 1908), 45.
13 Ise Gropius, "Autofahren in New York" (unpublished manuscript, 1929), Bauhaus-Archiv, Berlin.
14 Ralf Hütter, "Kraftwerk – Album By Album," interview by Stephen Dalton, *Uncut*, January 4, 2013.

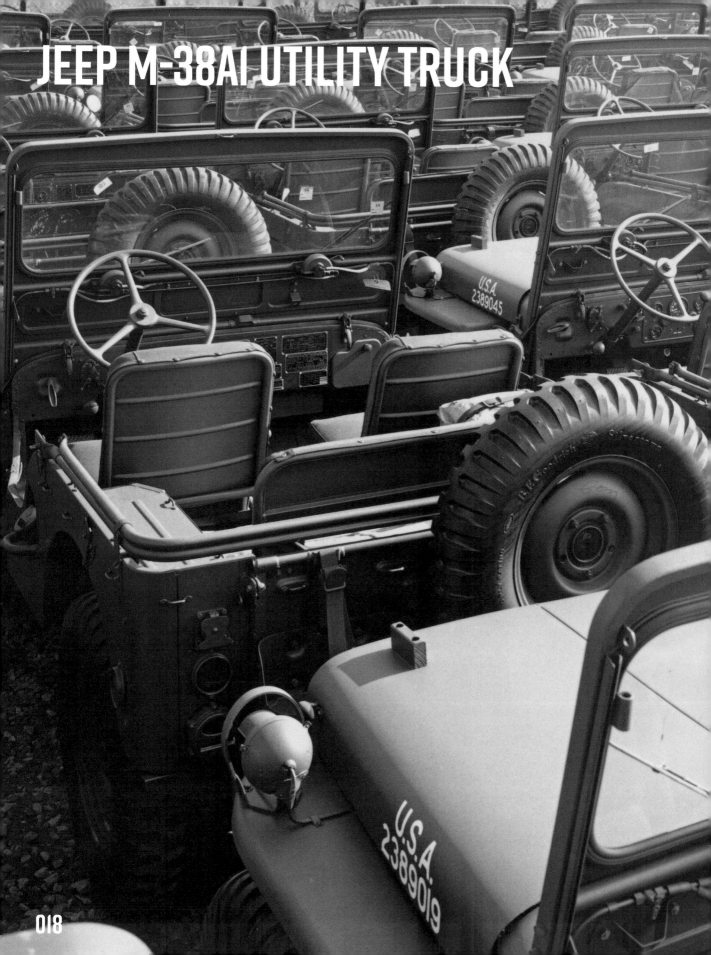

JEEP M-38A1 UTILITY TRUCK

Described as a "sturdy sardine can on wheels" by the MoMA curator Arthur Drexler in 1951, the Jeep is pragmatic, rational, and straightforward—qualities befitting a vehicle first developed for the American military. In June 1940 officials at the United States War Department, watching the outbreak of conflict across the world, sought a manufacturer for a light-weight all-terrain truck based on a design by the car company American Bantam. Willys-Overland Motors and the Ford Motor Company jumped into the fray and produced, together with Bantam, the first prototype of a combat-ready vehicle that came to be known as the Jeep. Its name likely derived from army slang for new recruits, though some historians contend that it came from "GP," the shorthand for "General Purpose" vehicle. By the war's end, nearly 360,000 Jeeps had been produced. By 1947 Willys-Overland was manufacturing Jeeps for both the military and civilian markets, and the company became synonymous with this new breed of rugged American four-wheel-drive vehicles.

A progenitor of today's SUVs, the M-38A1 is a faster, more robust version of the Jeeps manufactured during the early days of World War II. It is a car in which the very things that make it an exemplary machine are not hidden, but in fact exposed—a strategic design decision facilitating repair and replacement of the standardized parts. The windshield folds flat, and the wheels are removable, making it possible to stack and transport multiple vehicles at a time like boxes, a feature important for advanced military operations. In order to maximize ground clearance over rocky terrain, the body was designed to be flat and compact, with the gas tank tucked under the driver's seat for further streamlining. The open-air vehicle can be closed to the elements with a removable canvas top, while the lack of doors makes it easy to get in and out. The M-38A1 was the first Jeep to incorporate a rounded hood and fender, which, along with the distinctive front grille with inset headlamps— a carryover from the original WWII-era military Jeeps produced by Willys-Overland—are features that remain central to the design of the contemporary Jeep lineup.

—ANDREW GARDNER

Jeeps assembled for US military operations. Photograph by Alexandre Georges, reproduced in the catalogue for the exhibition *8 Automobiles*, The Museum of Modern Art, New York, August 28–November 11, 1951. MoMA Archives, New York

JEEP M-38A1 UTILITY TRUCK

Designed 1952 (this example 1953)
Manufacturer: **WILLYS-OVERLAND MOTORS, INC.** (Toledo, Ohio, est. 1909)

Steel body with canvas top, glass, rubber, and other materials
The Museum of Modern Art, New York.
Gift of DaimlerChrysler Corporation Fund

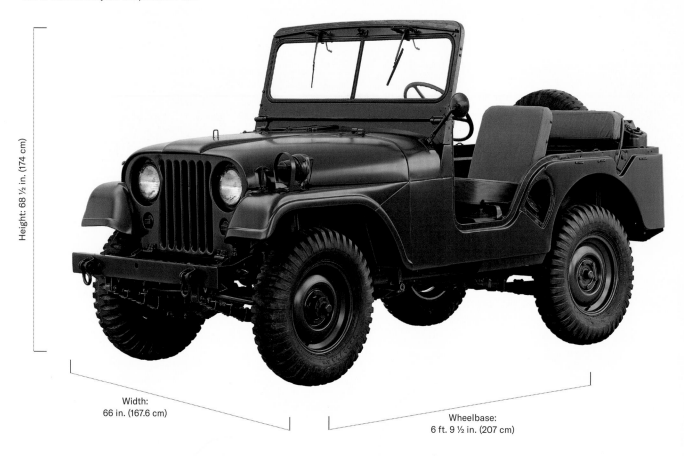

Height: 68 ½ in. (174 cm)

Width:
66 in. (167.6 cm)

Wheelbase:
6 ft. 9 ½ in. (207 cm)

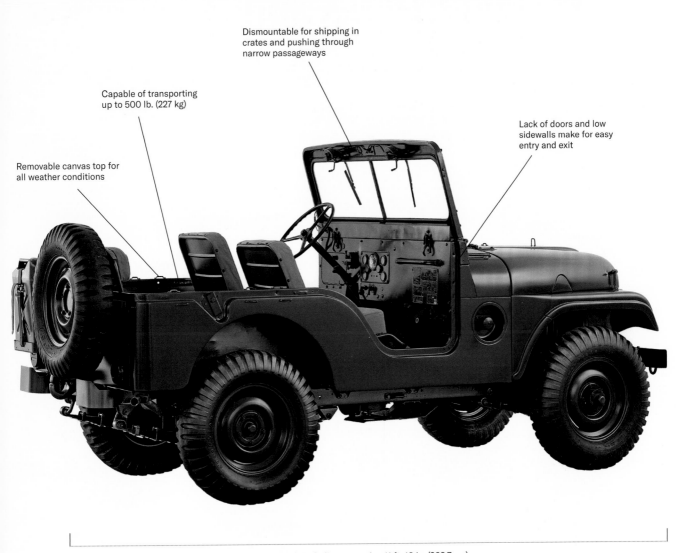

Removable canvas top for
all weather conditions

Capable of transporting
up to 500 lb. (227 kg)

Dismountable for shipping in
crates and pushing through
narrow passageways

Lack of doors and low
sidewalls make for easy
entry and exit

Length including spare tire: 11 ft. 10 in. (360.7 cm)

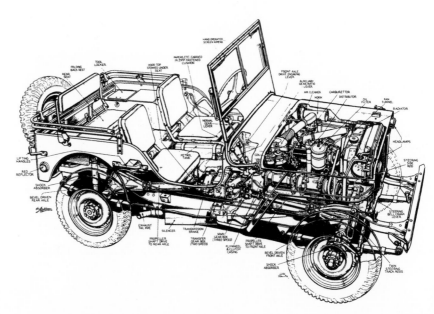

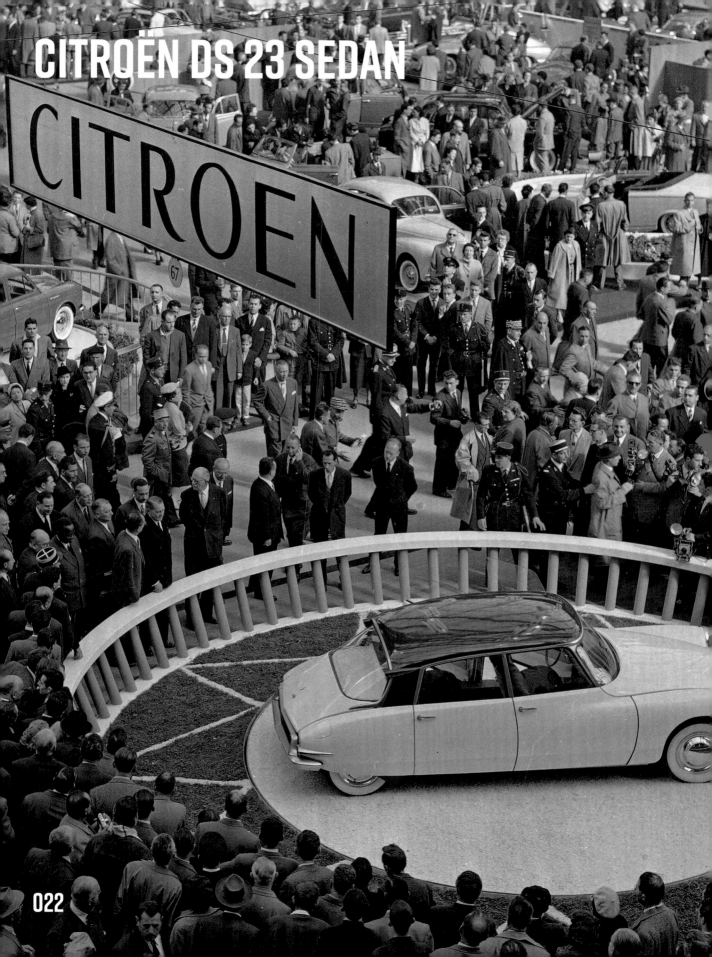

CITROËN DS 23 SEDAN

A contemporary of Henry Ford and Ferdinand Porsche, André Citroën founded his eponymous company in France in 1919. Like Ford and Porsche, he would go on to exert a lasting influence on automotive design—not only in his native country but worldwide. The culture of design excellence instilled by Citroën is evidenced by the company's production of the first front-wheel-drive car, the Traction Avant, in 1934, and the utilitarian and durable 2CV in 1948. Both of these cars were designed by the Italian car stylist Flaminio Bertoni, who was instrumental in establishing Citroën's reputation for technological innovation and manufacturing expertise. Trained as an artist and later as an architect, Bertoni brought a distinctive creative vision to an industry that, up to that point, had been dominated primarily by engineers. His 1954 design for the Citroën DS is considered his masterpiece; it remained largely unchanged until 1967, when the French designer Robert Opron made slight updates to the car.

Its name a clever play on the pronunciation of the French word *déesse* (meaning "goddess"), the large, expensive DS was clearly intended to appeal to the higher ambitions of the French people. Its debut at the 1955 Salon de l'Automobile in Paris caused a sensation, leading to a record number of preorders for an automobile (a record the DS held until it was surpassed by the Tesla Model 3 in 2016). To a French public still emerging from the destruction of the Second World War, the DS became a symbol of the country's resurgence. Bertoni's dramatic design combined the space-age elements common to American cars of the period with European aerodynamics and efficiency. Below the surface, the DS was packed with highly advanced technologies, including the first-ever hydropneumatic suspension system. Coupled with Michelin's new radial tires—a type of tire, then exclusive to the DS, that eventually became the industry standard—the suspension gave the car an unparalleled smooth ride, even over France's notoriously rough roads. Opron's 1967 redesign updated the front end, resulting in a more streamlined form, and also featured the first mass-market implementation of directional headlights, which turn in concert with the steering wheel and greatly improve visibility on dark, twisting roads.

Luxury executive cars like the DS were and remain powerful status symbols, embodying the aspirational lure of car ownership. In addition to being a great success throughout continental Europe, the DS was a particular favorite of French politicians. In 1962 Charles de Gaulle credited the sturdy DS in which he and his wife were riding for their survival of an assassination attempt. Despite it being riddled with bullets and having all four tires shot out, the improbably still-operable DS transported them to safety. A remarkable synthesis of aesthetic beauty and innovative engineering, the Citroën DS merits its widely regarded status as one of the most iconic French cars ever produced.

—PAUL GALLOWAY

The debut of the Citroën DS at the
1955 Salon de l'Automobile, Paris

CITROËN DS 23 SEDAN

Designed 1954–67 (this example 1973)
Designers: **FLAMINIO BERTONI** (Italian, 1903–1964),
ANDRÉ LEFÈBVRE (French, 1894–1964), **PAUL MAGÈS**
(French, 1908–1999), and **ROBERT OPRON** (French, born 1932)
Manufacturer: **CITROËN** (France, est. 1919)

Steel body with fiberglass top, glass, rubber, and other materials
The Museum of Modern Art, New York. Gift of Christian Sumi, Zurich,
and Sébastien and Pierre Nordenson

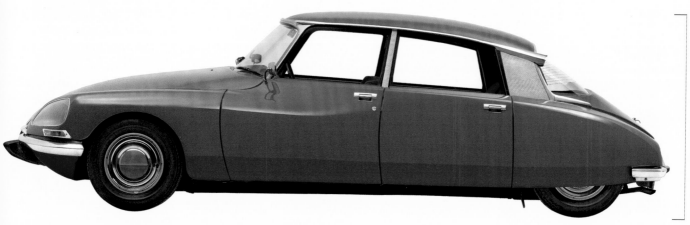

Height: 54 in. (137.2 cm)

Length: 15 ft. 11 in. (485.1 cm)

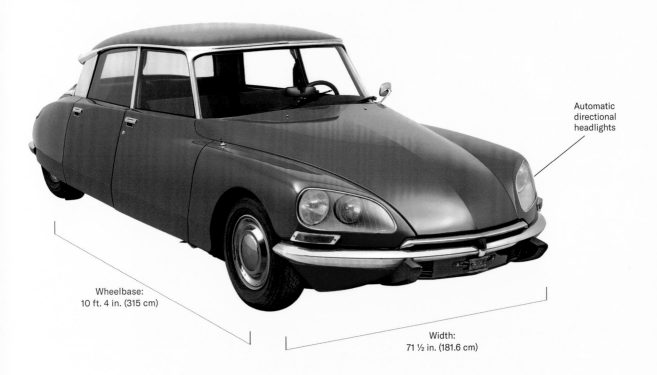

Automatic
directional
headlights

Wheelbase:
10 ft. 4 in. (315 cm)

Width:
71 ½ in. (181.6 cm)

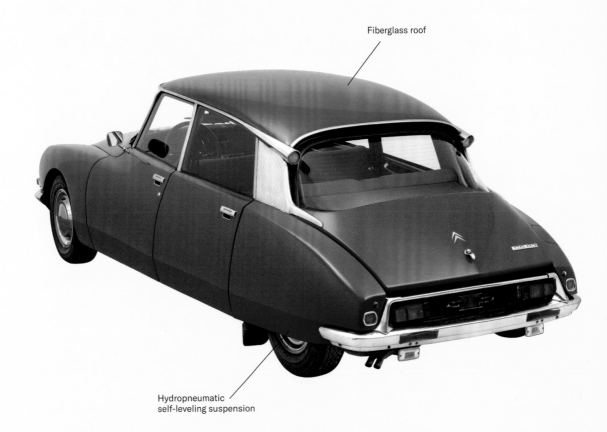

Fiberglass roof

Hydropneumatic
self-leveling suspension

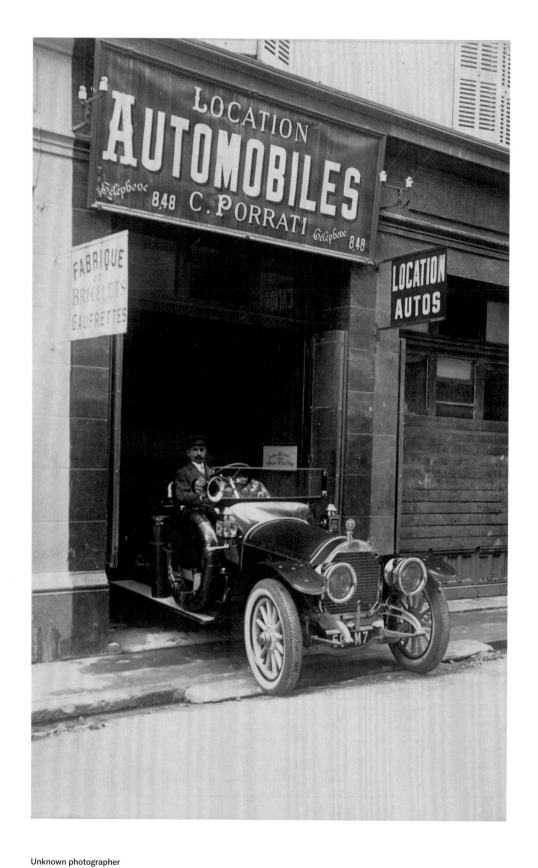

Unknown photographer
Automobiles, C. Porrati, 4, rue Lafontaine, Plaque Guilleminot, Cannes. Postcard. c. 1905
Gelatin silver print with ink, approx. 5 ½ × 3 ⁹/₁₆ in. (14 × 9 cm)
The Museum of Modern Art, New York. Acquired through the generosity of Jon L. Stryker
and Committee on Photography Fund

I. THE MANIA BEGINS

What to call the newfangled, self-propelled contraptions that began to appear in industrialized centers around the world in the 1890s? Journalists worked hard to coin a name that might stick, among them "carlock," "electromobile," "autocar," "automotor," "motocycle," "propeller," "cabine," "autocab," "motor wagon," "horseless carriage," "self motor," "automaton," "auto-locomotors," "polycycle," and "autobaine." By 1895, however, the United States seems to have plumped for the French word *automobile*, reflecting France's early supremacy in the nascent industry. France led the world in the number of automobiles produced until overtaken by the US around 1906 (opposite; fig. 1). Stimulated by reports from Europe extolling the virtues and successes of this invention, the recently founded American Automobile Club held its first parade in New York in 1899, which gave the city "a foretaste of the century to come": "For the first time since the early Dutch settlers of New Amsterdam astonished the natives with their wheeled carts and wagons, the people of Manhattan beheld some of their prominent fellow citizens gliding through the town. . . . Thousands of people thronged the entire route of the parade," recounted one attendee. "All styles of machines and vehicles put in an appearance. . . . Uniformed and liveried grooms were perched behind, and fair women . . . sat beside the drivers."[1] (Later that same year,

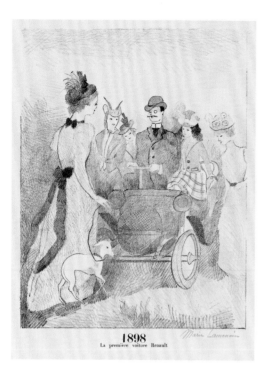

New York was the setting for another, unwelcome first: the first recorded motor vehicle fatality in the Western Hemisphere.) At this point cars were primarily play-things for the well-heeled and adventurous; nobody bought a car to commute or run errands. On top of the original purchase of the vehicle itself, fuel, mainte-nance, and all the associated trappings involved major outlay. Part of a culture that upheld driving as a pastime of the elite, motoring clubs offered exclusive din-ing and social facilities. The eldest and most prestigious organization of this kind, the Paris-based, men-only Automobile Club de France maintained costly winter premises in the Place de l'Opéra and a summer villa in the Bois de Boulogne, mov-ing to a yet more prestigious setting in the Place de la Concorde in 1898.

For those who could afford cars, driving created opportunities to make fashion statements—albeit, again, for a price. In women's case, dresses specially designed for driving also allowed for new physical freedoms: "To guide an automobile one must have free use of the limbs. To attain this end the Parisian modistes have designed a gown of silk jersey. The costume is very expensive, one dress costing no less than $500," reported *The Automobile Magazine* in 1899.[2] Because early cars featured open cabins, exposing drivers to the elements, goggles, caps, gaiters, gauntleted gloves, and enormous overcoats were deemed essential wear for men. Dr. Gabriel Tapié de Céleyran was depicted in the full kit by his cousin Henri de Toulouse-Lautrec in a lithograph titled *The Automobile Driver* (*L'Automobiliste*, 1898; fig. 2), which was printed for circulation among family and friends. The print shows Tapié de Céleyran staring fixedly ahead as he steers his high-end bit of machinery forward, leaving a trail of dust and fumes in his wake. His fur coat bristles like that of an animal, merging with the propulsive form of the car as he chugs past a Parisian woman walking a small yapping dog; their forms, faintly delineated, melt flickeringly away. The French poet Octave Mirbeau described motorists as "the worst of all animals on the road" in an account of his own motoring escapades, published in 1907 with lively sketches by his friend Pierre Bonnard (fig. 3). "I am aware of it myself. . . . When I am in the car, possessed by speed, humanitarian feelings drain away," Mirbeau

1.
Marie Laurencin (French, 1883–1956)
The First Renault Car, 1898 (*La Première voiture Renault, 1898*). 1936
Lithograph, comp.: 14 × 10 ⅞ in. (35.5 × 27.7 cm); sheet: 25 ⅜ × 19 ⁷⁄₁₆ in. (64.4 × 49.3 cm)
The Museum of Modern Art, New York. Purchase

2.
Henri de Toulouse-Lautrec (French, 1864–1901)
The Automobile Driver (*L'Automobiliste*). 1898
Lithograph, comp.: 14 ¾ × 10 ½ in. (37.4 × 26.6 cm); sheet: 19 ¾ × 14 in. (50.1 × 35.5 cm)
Publisher: probably the artist, Paris
Edition: 25
The Museum of Modern Art, New York. Gift of Abby Aldrich Rockefeller

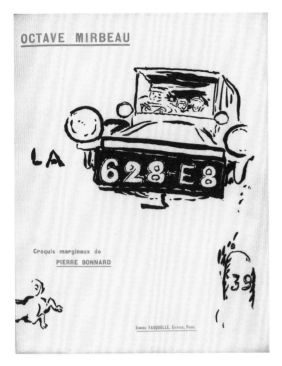

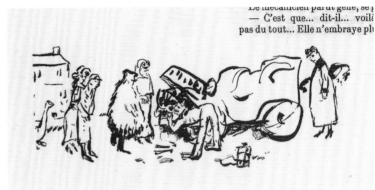

confessed. "I begin to feel obscure stirrings of hatred and an idiotic sense of pride. No longer am I a miserable specimen of humanity, but a prodigious being in whom are embodied—no please don't laugh—Elemental Splendor and Power. . . . Imagine with what contempt I view the rest of humanity from the vantage point of my car. . . . Out of my way!"[3]

Perhaps the most compelling evocation of this emerging mania and its attendant dangers is to be found in Kenneth Grahame's ever-popular children's book, *The Wind in the Willows*, first published in 1908 (fig. 4). The peaceful environment and simple pleasures the protagonist Mr. Toad shares with his anthropomorphized friends Ratty, Mole, and Badger are shattered by Toad's first eye-popping encounter with an otherworldly contraption that drives his horse-drawn caravan off the road:

Glancing back, they saw a small cloud of dust, with a dark centre of energy, advancing on them at incredible speed, while from out the dust, a faint "Poop poop!" wailed like an uneasy animal in pain. . . . And with a blast of wind and a whirl of sound that made them jump for the nearest ditch, It was on them! . . . The magnificent motorcar, immense, breath-snatching, passionate, with its pilot tense and hugging his wheel, possessed all earth and air for the fraction of a second, flung an enveloping cloud of dust that blinded and enwrapped them utterly, and then dwindled to a speck in the far distance.[4]

Toad soon develops a thrill-seeking addiction to motoring, later channeling the supercharging power of the car: "As if in a dream, all sense of right and wrong, all fear of obvious consequences, seemed temporarily suspended. He increased his pace, and as the car devoured the street and leapt forth on the high road through the open country, he was only conscious that he was Toad once more, Toad at his best and highest, Toad the terror, the traffic-queller, the Lord of the lone trail, before whom all must give way or be smitten into nothingness and everlasting night."[5] Yet in reality he is a terrible driver who embarks on a self-destructive

3.
Pierre Bonnard (French, 1867–1947)
Cover and illustration (page 46) from *La 628-E8*, by Octave Mirbeau. 1908
Illustrated book with 104 line block reproductions after drawings (including front cover), page (each): 9 7/16 × 7 9/16 in. (24 × 19.2 cm); overall (closed): 9 3/4 × 7 9/16 × 1 3/8 in. (24.7 × 19.2 × 3.5 cm)
Publisher: Eugène Fasquelle, Éditeur, Paris
Printer: Motteroz et Martinet, Paris
Edition: 225
The Museum of Modern Art, New York.
The Louis E. Stern Collection

bender that results in seven smashed-up cars, multiple injuries, a small fortune in fines, and a stiff prison sentence. Still in print, *The Wind in the Willows* has mesmerized generations of children and adults and given rise to numerous films and one of Disney's most popular amusement park attractions, Mr. Toad's Wild Ride.

The perceived connection between driving and intoxicating sensual experience is communicated unambiguously in a 1907 poster advertisement for the Swedish company Bil-Bol designed by the renowned Finnish artist Akseli Gallen-Kallela (fig. 5). (Short for Bil Aktiebolaget—literally "Car Company Incorporated"—Bil-Bol specialized in luxury cars and ran a service that ferried wealthy clients around Stockholm on trips to and from high-class events such as plays and dinner parties.) The phallic form of the car blazes through the night sky, reminiscent of the infernal vehicle dubbed "the Terror" in Jules Verne's 1904 novel *Master of the World*, which moved like a thunderbolt and put its master in command of "invisible and infinite satanic powers."[6] The poster's begoggled motor-maniac, who drives one-handed, would have been recognizable to the target Nordic audience as Carl Cederström, Bil-Bol's eccentric CEO. Locally known as the "flying baron," Cederström could often be seen zooming around the Swedish capital in his cars or racing boat with well-known friends and cultural personalities. It was possibly in Paris, where he spent a brief stint as a singer-songwriter, that Cederström first encountered the work of Gallen-Kallela, whose murals were exhibited in the Finnish pavilion at the 1900 World's Fair to international acclaim. Painted in a National Romantic style (a Nordic variation of Art Nouveau), the murals portrayed scenes from Finland's national epic, the *Kalevala* (Land of heroes). Gallen-Kallela returned to this source for the Bil-Bol poster, choosing the episode in which the daredevil hero Lemminkäinen abducts a beautiful maiden named Kyllikki. In updating the tale's traditional wood sled to a magnificent Bil-Bol car, the brand sought to achieve a mythic and timeless resonance. Nationalist sentiment was riding high in Finland, where a campaign for political independence from Russia was being waged, and the poster's symbolically rich imagery was part of crafting a unique identity for the country as modern, autonomous, and industrialized.

4.
David Petersen (American, born 1977)
Mr. Toad driving his automobile. Illustration from *The Wind in the Willows* (1908), by Kenneth Grahame. 2016
Published by IDW, San Diego

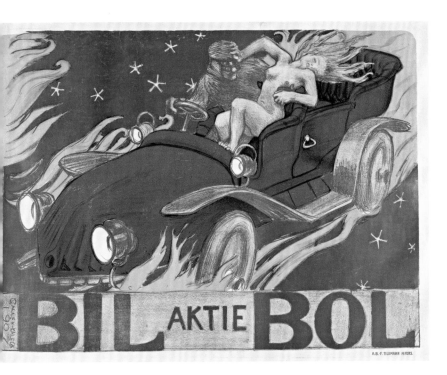

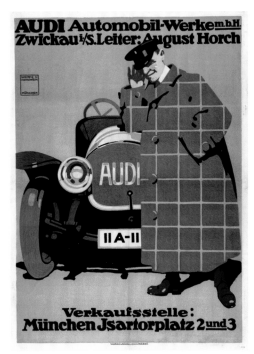

By 1900 improvements in lithographic printing and distribution had made posters an ideal and accessible art form with which to advertise the automotive industry in an increasingly international marketplace. In Germany there was a synergy between Audi, already one of the best-known German automobile brands, and the Munich-based Ludwig Hohlwein, among the most innovative graphic designers of his era. Audi's founder, the engineer August Horch, commissioned Hohlwein to design an advertisement for the Type C (fig. 6), a sporty touring car that was released in 1911 and at whose wheel Horch won—three years in a row—the Austrian Alpine Rally, then the most grueling event of its kind. Hohlwein's scheme for the poster, which shows Horch cupping his ear to listen to the reliable purr of the engine, is a witty play on the company's name and that of its founder: *audi* is the Latin equivalent of *horch*, which means "listen" in German. The visual impact of this concept is amplified by the combination of boldly simplified image, minimal text, and high-key colors. Overlapping elements—the gray car grill merging with Horch's plaid coat, whose tiled squares are the same size as Hohlwein's signature-square on the far left—and repeating geometric shapes create a compositional harmony, connecting the brand, company owner, and graphic designer under a shared ethos of efficiency, rationality, and technological progress.

The German auto industry excelled in precision mechanics and electrical engineering, lending to its success in the international market, where technical reliability and the standardization of parts to facilitate repairs were major consumer concerns. For the industrialist Robert Bosch's eponymous car parts company, established in Stuttgart in 1886, sales outside Germany accounted for almost 90 percent of its overall revenue by 1913. Bosch's star product was its magneto ignition system, which fired up cars' combustion engines around the globe from the time it was patented in 1897 until World War I. The artist Lucian Bernhard designed a poster for Bosch in 1914 that isolated an essential component of this system: the spark plug (fig. 7). Along with Hohlwein, Bernhard was a leading exponent of the modern *Sachplakat* (or "object poster") that eliminated all extraneous verbiage and decoration, leaving the viewer to focus on the product itself and

5.
Akseli Gallen-Kallela (Finnish, 1865–1931)
Poster for Bil Aktiebolaget (Car Company Inc.). 1907
Lithograph, 34 ¼ × 45 in. (87 × 114 cm)
Printer: A.B.-F. Tilgmann, Helsinki
The Museum of Modern Art, New York. Purchase and gift of Aivi and Pirkko Gallen-Kallela

6.
Ludwig Hohlwein (German, 1874–1949)
Poster for Audi Automobil-Werke. 1912
Lithograph, 49 ⅛ × 36 in. (124.8 × 91.4 cm)
Printer: G. Schuh & Cie, Munich
The Museum of Modern Art, New York. Gift of The Lauder Foundation, Leonard and Evelyn Lauder Fund

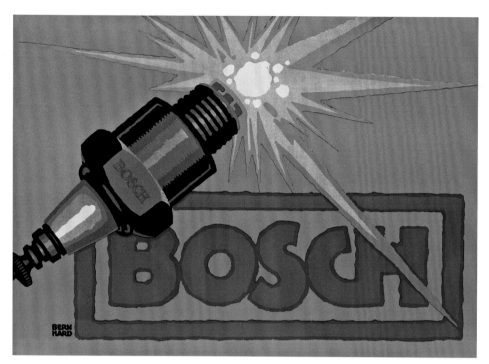

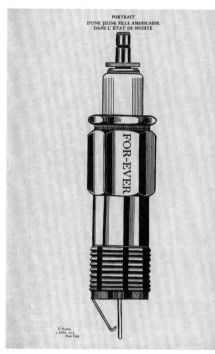

brand name. Bernhard's poster design for Bosch sets a dramatically enlarged spark plug and the company logo against a bright orange ground, illustrating the explosive moment of ignition that will conjure the engine into life. A spark plug advertisement was likewise the subject of Francis Picabia's *Portrait of a Young American Girl in a State of Nudity* (*Portrait d'une jeune fille américaine dans l'état de nudité*), a collage that was reproduced in a 1915 issue of the American avant-garde art and literary magazine *291* (fig. 8). *Portrait of a Young American Girl* appeared in a spread alongside the artist's self-portrait as a car horn. Picabia made these designs during a trip to New York, where he had become convinced that "the genius of the modern world is machinery, and that through machinery art ought to find a most vivid expression."[7]

This sentiment was shared by Giacomo Balla and his fellow artists in the Italian Futurist movement, who were obsessed with the accelerated tempo, noise, and ruptures of the mechanized world. Inspired in part by photographic studies of animal locomotion (such as those by the French physiologist Étienne-Jules Marey), Balla made more than one hundred studies of automobiles that attempted to express their dynamism and create layered impressions of their movement through space. One such study, the 1912 painting *Speeding Automobile*, is built up of kaleidoscopic, fractured planes and overlapping lines that appear to disintegrate and multiply, registering the energy, light, and sounds that emanate from the car (fig. 9). Concurrently in France, the self-taught photographer Jacques-Henri Lartigue also experimented with capturing the speed and spectacle of car travel. From a well-off and technically savvy family, Lartigue was gifted his first camera at a young age, building his skill in clicking the shutter by taking photos of the many horse, car, and motorcycle races he attended growing up. Perhaps some of his most iconic images were of the 1912 Grand Prix of the Automobile Club de France, in which cars appear blurred, tilted, and cropped as a result of Lartigue's fresh technique of moving with the camera as he shot (see pages 6–7).

7.
Lucian Bernhard (American, born Germany. 1883–1972)
Poster for Bosch spark plugs. 1914
Lithograph, 17 ⅞ × 25 ¼ in. (45.5 × 64.2 cm)
The Museum of Modern Art, New York. Gift of The Lauder Foundation, Leonard and Evelyn Lauder Fund

8.
Francis Picabia (French, 1879–1953)
Portrait of a Young American Girl in a State of Nudity (*Portrait d'une jeune fille américaine dans l'état de nudité*), from the journal *291*, edited by Paul Haviland, Agnes Ernst Meyer, Alfred Stieglitz, and Marius de Zayas. New York, July–August 1915
Deluxe letterpress edition, page: 17 ¼ × 11 ⅜ in. (43.8 × 28.9 cm)
The Museum of Modern Art Library, New York. Acquired through the generosity of The Library Council; The Trustee Committee on Museum Archives, Library, and Research; and Kathy Fuld, Marie-Josée Kravis, Philip E. Aarons, Barbara Jakobson, Gilbert Silverman, Werner H. Kramarsky, Kathleen Lingo, and Elaine Lustig Cohen

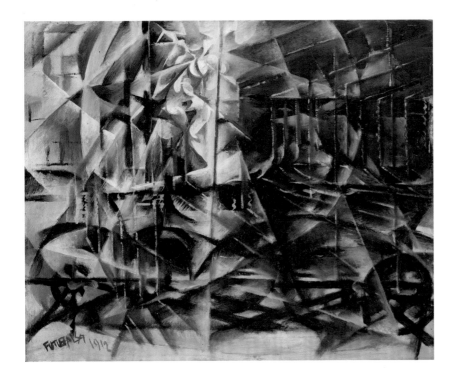

1 Edgar S. Hyatt, "Our First Club Run," *Automobile Magazine*, December 1899, 245–46.

2 Edwin Emerson, Jr., "Newport in the Lead," *The Automobile Magazine*, October 1899, 8.

3 Octave Mirbeau and Pierre Bonnard, *Sketches of a Journey: Travels in an early motorcar; From Octave Mirbeau's journal 'La 628-E8' with illustrations by Pierre Bonnard*, trans. D. B. Tubbs (London: Philip Wilson Publishers in association with Richard Nathanson, 1989), 131–32.

4 Kenneth Grahame, *The Wind in the Willows* (London: Methuen, 1908), 15.

5 Ibid., 48.

6 Jules Verne, *Master of the World* (New York: Ace Books, 1951), 165.

7 Francis Picabia, quoted in "French Artists Spur on an American Art," *New York Tribune*, October 24, 1915, part IV, 2.

9.
Giacomo Balla (Italian, 1871–1958)
Speeding Automobile. 1912
Oil on wood, 21 ⅞ × 27 ⅛ in. (55.6 × 68.9 cm)
The Museum of Modern Art, New York. Purchase

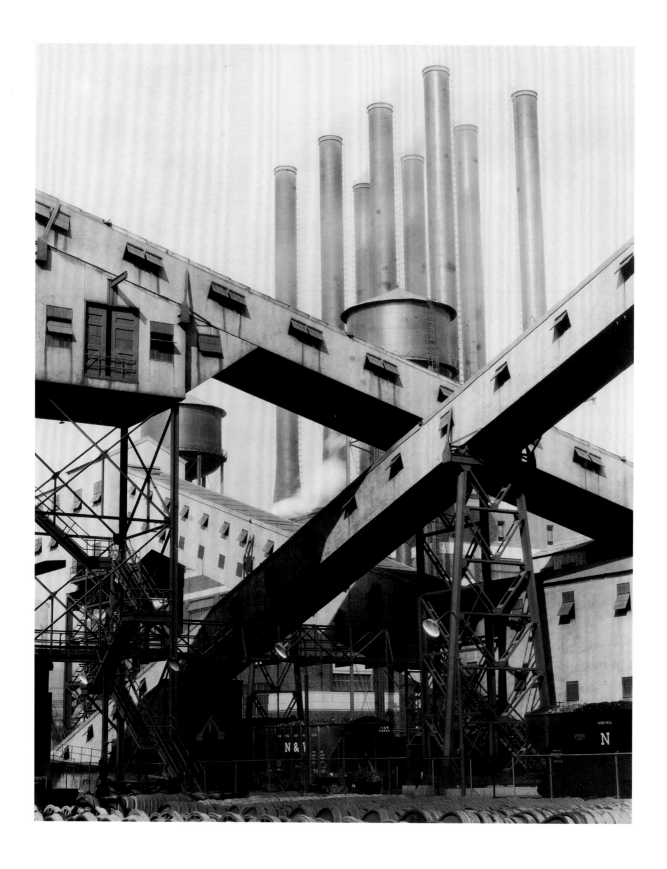

034

Charles Sheeler (American, 1883–1965)
Criss-Crossed Conveyors, River Rouge Plant, Ford Motor Company. 1927, printed 1941
Gelatin silver print, 9 ⅜ × 7 ½ in. (23.9 × 19 cm)
The Museum of Modern Art, New York. Gift of Lincoln Kirstein

2. MASS PRODUCTION FOR A MASS MARKET

The United States commenced the twentieth century with its first national automobile exhibition, which showcased 160 "horseless carriages" powered by an impressive array of electric, steam, and combustion engines. Taking place at Madison Square Garden in New York City, the spectacle drew some forty-eight thousand visitors, each paying a stiff entry fee of fifty cents. A high-end market was primed, and the future clearly belonged to the metal beasts on display. But few could have anticipated the imminent mass proliferation of the combustion engine, which burned fuel in a closed chamber to generate energy, and the far-reaching influence it would have on modern mobility and the global economy. (Of the three engine technologies on offer, the "steamers" and "electrics" were thought to have the most potential, with the combustion or "internal explosion" engines coming in last.) This development can be attributed to the enterprising American industrialist Henry Ford, whose eponymous company, established in 1907, would transform the industry from the bottom up. Ford's founding vision was to build "a motor car for the great multitude" that would be "large enough for the family but small enough for the individual to run and care for" and "constructed of the best materials, by the best

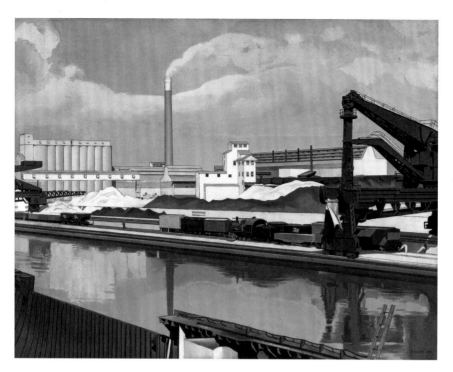

men to be hired, [and] after the simplest designs that modern engineering can devise." "But," he added, "it will be so low in price that no man making a good salary will be unable to own one—and enjoy with his family the blessing of hours of pleasure in God's great open spaces."[1] These aspirations gave birth to the Model T—or "Tin Lizzie," as it became colloquially known—which trundled out of Ford's Highland Park factory in Michigan for the first time in 1908. He outfitted the automobile with a combustion engine, an engine type that he had first encountered as a young apprentice machinist. Five years later, in 1913, Ford introduced his most momentous innovation, one that would revolutionize labor practices and productivity not just in auto manufacturing but across industries: the moving assembly line, which streamlined the flow of production by using semiskilled labor for repetitive tasks. By sticking to the basic Model T and using standardized parts and a strictly limited range of colors and add-ons, Ford was able to manufacture fifteen million cars over the next eighteen years.

The colossal River Rouge complex completed in Dearborn, Michigan, in 1928 pushed Ford's vision still further. As the largest integrated factory in the world, rationally planned and with modernist buildings designed by Albert Kahn, it attracted a steady stream of manufacturers, architects, designers, and photographers, all eager to observe and learn from this uniquely American and spectacular iteration of industrial capitalism. Following a visit to River Rouge in 1935, the Czechoslovakian architect Antonin Raymond wrote breathlessly to his wife Noémi:

The plant—12,000 acres of amazing buildings—True to their purpose—wonderful—Tremendous roads, autos by 10,000s, cannot see the end of parking space, cars, cars, cars melting with the horizon—Chauffeur guiding me through long vistas, miles long of machines, glistening, perfect, all in perfect alignment. . . . Steel steps, tube railings—enormous windows—everything multiplied—over and over again to the horizon—4,500 of cars, every day, from rocks, stones, ore, etc. etc.—sand piles, ore piles, steel piles, glass piles, piles, piles of innumerable parts—boilers,

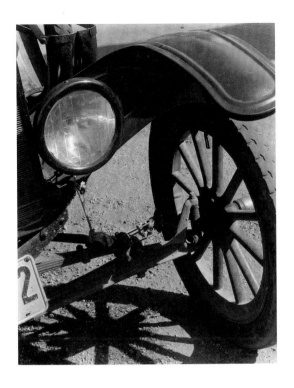

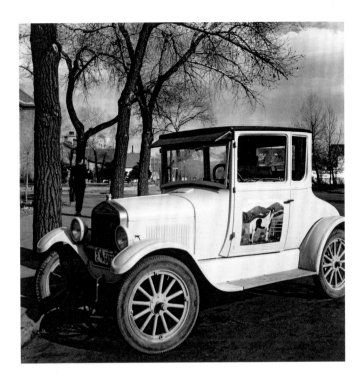

200 feet high, purple windows to see the flame—2,500 tons of powdered coal they eat in a day—they produce 10,000s or 100,000s of kilowatts of electricity— the boiler controlled by levers by one man like an aeroplane.[2]

Charles Sheeler painted and photographed this newly quintessential American landscape (fig. 1) in the belief that "our factories are our substitutes for religious experience."[3] He and Margaret Bourke-White—the first photographer to join the staff of *Fortune* magazine in 1930 and then its sister magazine *Life* in 1932— produced publicity photographs of Ford's River Rouge plant in 1927 (see page 34; fig. 2). These images emphasize geometric structural elements, sharp tonal contrast, and radical perspectives, exemplifying a style that came to be known as "straight" or "objective" photography.

In large part because of Ford's transformative model of production, cars were no longer just a plaything for the rich but an accepted part of everyday urban and rural life. A photograph the artist Ralph Steiner took of a Model T in 1929 highlights the car's skeletal, almost rudimentary structure and the underlying geometry of its headlamp, wheel, and shadow (fig. 3). At the same time, the dusty bodywork, worn tire treads, and encrusted brackets—traces of its punishing daily use—are thrown into relief. Although no people are in the shot, the car documents the lived experience of swaths of Americans at the time. A 1936 photograph by John Gutmann of a cowboy's workaday Model T in Wyoming makes a markedly different statement about life during the Depression era (fig. 4). A Jewish refugee from Nazi Germany, Gutmann traveled around the country on Greyhound buses, observing American cars and popular culture with an outsider's eyes. Details such as the perfectly painted horse on the door of the cowboy's car—an early example of creative customization—struck him as a revelation of his adopted country's enormous vitality.

Neither unique decoration of this kind nor the inelegant appearance and clunky construction of the Model T sat easily with the Eurocentric view of modernism promoted by MoMA in the 1930s.[4] The machine aesthetic of isolated

3.
Ralph Steiner (American, 1899–1986)
Ford Car, Ford Headlight and Wheel. 1929.
Gelatin silver print, 9 9/16 × 7 9/16 in. (24.3 × 19.2 cm)
The Museum of Modern Art, New York. Gift of the artist

4.
John Gutmann (American, born Germany. 1905–1998)
A Cowboy's Car, Wyoming. 1936
Gelatin silver print, 7 11/16 × 7 11/16 in. (19.5 × 19.5 cm)
The Museum of Modern Art, New York. John Gutmann Bequest

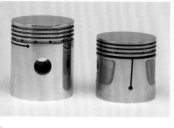

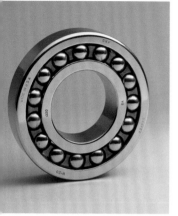

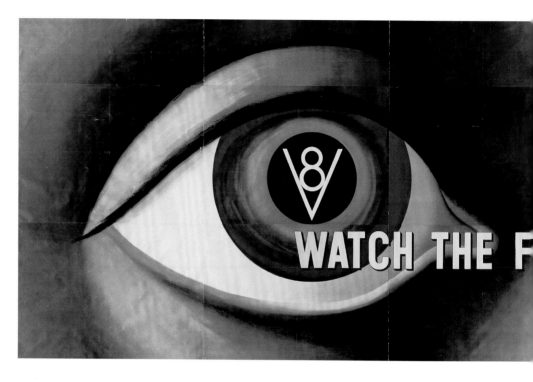

component parts was, however, more readily embraced as evidence of a new technologically driven style that the US was making its own. In *Machine Art*—MoMA's first exhibition of industrial art, organized by founding director Alfred H. Barr, Jr., and architecture curator Philip Johnson in 1934—car pistons, ball bearings, headlamps, a taillight, and a dashboard clock were among more than six hundred items taken to demonstrate the ubiquity of a machine aesthetic in modern life (figs. 5, 6). The installation was theatrical and dramatically lit, divorcing these items from the contexts of their social use and the labor that produced them. By staging at MoMA a show of car parts and other objects traditionally excluded from art museums, Barr and Johnson deliberately challenged conventional perceptions of what qualified as art, building on the founding mission of the Museum to present the full range of modern visual arts to the North American public.

In an increasingly consumer-oriented economy, effective advertising was key. Ford was the first manufacturer to develop a car with a V8 engine, previously exclusive to luxury and specialist cars, for a mass market—an achievement the company publicized extensively. The copy for a 1935 advert boasted: "V-8 has come to mean Ford. . . . Yet it has not been long since the V-8 car was only for the well-to-do. . . . Ford methods have made the full measure of performance, comfort, safety, beauty and convenience—once only enjoyed by the limited few—available to all at a low price." To infuse their corporate reputation for industrial innovation with some of the artistic cachet of European modernism, Edsel Ford—who had taken over the family business from his father, Henry, in 1919—commissioned a billboard from the preeminent French poster artist A. M. Cassandre in 1937 (fig. 7). Edsel had long been more artistically inclined than his father and was philanthropically connected with MoMA, where he had been inspired by an exhibition of Cassandre's work in 1936—the first solo show in the Museum devoted to a graphic designer. Cassandre, who designed to answer certain strictly material and commercial needs, saw an affinity between the poster and the automobile as mass-produced objects existing in thousands of copies. In his billboard for

5.
Aluminum Company of America (United States, est. 1888)
Automobile pistons. 1924–34
Aluminum alloy, 3 ¾ × 3 ¼ in. (9.5 × 8.2 cm) and 2 ¹⁵⁄₁₆ × 3 ¹⁄₁₆ in. (7.5 × 7.8 cm)
The Museum of Modern Art, New York. Gift of the manufacturer

6.
Sven Wingquist (Swedish, 1876–1953)
Self-aligning ball bearing. 1907
Chrome-plated steel, 1 ¾ × 8 ½ in. (4.4 × 21.6 cm)
Manufacturer: S.K.F. Industries, Inc., Hartford, Connecticut
The Museum of Modern Art, New York. Gift of the manufacturer

7.
A. M. Cassandre (French, 1901–1968)
Watch the Fords Go By. Poster for Ford Motor Company. 1937
Lithograph, 8 ft. 11 in. × 19 ft. 6 ½ in. (271.8 × 595.6 cm)
The Museum of Modern Art, New York. Gift of the designer

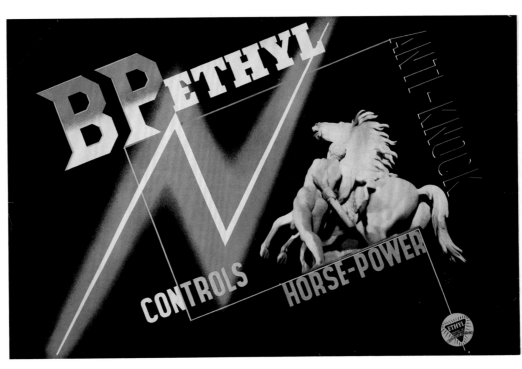

Ford, the compelling image of a disembodied, all-seeing eye emblematizes the primacy of sight within a Western classical tradition; the eye is also a common motif in Surrealist art of the 1920s. Trailing from the iris, the slogan "Watch the Fords Go By" gives a sense of modern vision, always in motion, while the V8 icon imprinted on the pupil suggests a fusion of mind, body, and technology—a synthesis that revolutionized perceptions of space and time in the modern world, above all through the motorcar.

In the late 1930s Barr acquired this Cassandre billboard along with a huge number of posters advertising the Shell-Mex and BP Ltd petroleum company (fig. 8); these have since become highlights of MoMA's collection of graphic design and remain sought-after collectibles. But they do not necessarily reflect the general style and tenor of auto advertising at the time. Indeed, Bourke-White captured a more representative billboard when she traveled to Louisville, Kentucky, in 1937 to cover a devastating flood for *Life* magazine (fig. 9). Published in the February issue, the photo shows a group of people, all African American, waiting in line outside a relief station. Behind them looms a billboard of a super-sized grinning white family of four in a car, with text declaring, "World's Highest Standard of Living . . . There's no way like the American Way." The irony of the billboard's message was inescapable; as the magazine caption wryly observed, "It was going to take a lot of money to restore the American standard of living in the cities and towns of the Ohio Valley." Signaling the larger issue of racial inequality in the US, the photograph cracked apart the myth of the American dream with which car ownership had become associated.

By the late 1930s the wider negative repercussions of Ford's industrial paradigm were also coming under fire. Charlie Chaplin's film *Modern Times* (1936), for instance, offered a biting critique of the physical and psychological toll on assembly-line workers. Trapped on an accelerating conveyor belt where he tightens nuts at an ever-increasing rate, Chaplin eventually suffers a nervous breakdown, ending up in the hospital after getting mangled in the factory machinery (fig. 10). The relentless pace of labor that *Modern Times* lampooned

8.
E. McKnight Kauffer (American, 1890–1954)
BP Ethyl Anti-Knock Controls Horse-Power.
Poster for Shell-Mex BP Oil. 1933
Lithograph, 30 × 45 in. (76.2 × 114.3 cm)
The Museum of Modern Art, New York. Gift of
Shell-Mex BP

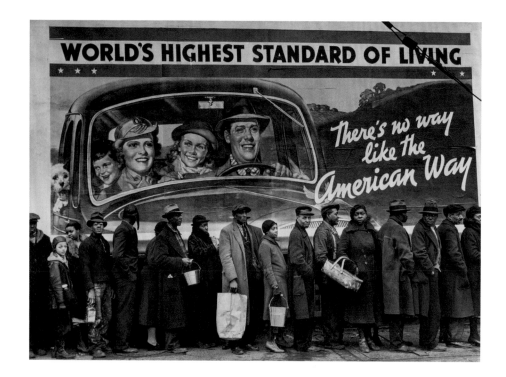

9.
Margaret Bourke-White (American, 1904–1971)
At the Time of the Louisville Flood. 1937
Gelatin silver print, 9 ¾ × 13 ⅛ in. (24.7 × 33.4 cm)
The Museum of Modern Art, New York. Gift of
the artist

had been determined two decades earlier, in 1913, when Ford commissioned moving-image documentation of his workers' movements as part of time and motion studies to eradicate "wasted motion." The intrinsically kinetic and mechanical medium of film was in many ways ideally suited to the subject of automobiles' production, with one contemporary journalist even describing the assembly line at Ford's Highland Park factory as "like the successive negatives on a motion picture film."[5] In 1914 Ford established its own Motion Picture Department, which propagandized its role in the furtherance of industrial progress and created some of the most widely distributed films of the silent era.

Ultimately critiques of the Fordist model of production could not arrest its spread nor seriously compete with the glamorous and wildly popular presentation of corporate capitalism displayed by automobile manufacturers at the world's fairs in Chicago ("A Century of Progress," 1933–34) and New York ("The World of Tomorrow," 1939–40). An estimated ten to twenty-five million visitors in New York queued up to experience "Futurama" in the General Motors complex, a dazzling multimedia installation that cost GM more than seven million dollars. Conceived by Norman Bel Geddes, an American theatrical and industrial designer, the exhibit featured a giant diorama of a city in the year 1960, whose intricate systems of freeways and skyscrapers offered an upbeat, panoramic, and overwhelmingly car-centric view of the future. On the way out, visitors were given a lapel button that proclaimed, "I Have Seen the Future." By the time 1960 came around, the labor and marketing practices initiated by Ford had indeed been emulated worldwide by companies keen to develop new compact and affordable cars for a mass market. Among these efforts were the Volkswagen, or "people's car," of Hitler's Germany (see pages 42–45) and the Fiat Cinquecento (see pages 46–49), which became a symbol of Italy's postwar reconstruction. As vital boosts to employment and exports in both countries, these cars inspired hope that the automobile sector would also trigger social and economic mobility among the wider populace, as it had in the US.

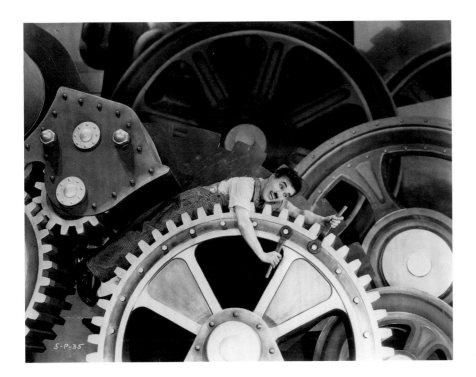

1 Henry Ford, *My Life and Work* (Garden City, NY: Doubleday, Page, 1922), 73.
2 Antonin Raymond to Noémi Raymond, Detroit, October 29, 1935, in *Crafting a Modern World: The Architecture and Design of Antonin and Noémi Raymond*, ed. Kurt G. F. Helfrich and William Whitaker (New York: Princeton Architectural Press, 2006), 333.
3 Charles Sheeler, quoted in Constance Rourke, *Charles Sheeler: Artist in the American Tradition* (New York: Harcourt, Brace, 1938), 130.
4 The irregular appearance of the Model T was in part due to the fact that its various components were initially produced by independent suppliers, as was typical of early mass-produced cars.
5 Horace Lucien Arnold and Fay Leone Faurote, *Ford Methods and the Ford Shops* (New York: Engineering Magazine Company, 1915), 360.

10.
Charles Chaplin (British, 1889–1977)
Modern Times. 1936
Produced by Charles Chaplin Productions
The Museum of Modern Art, New York

VOLKSWAGEN TYPE 1 SEDAN

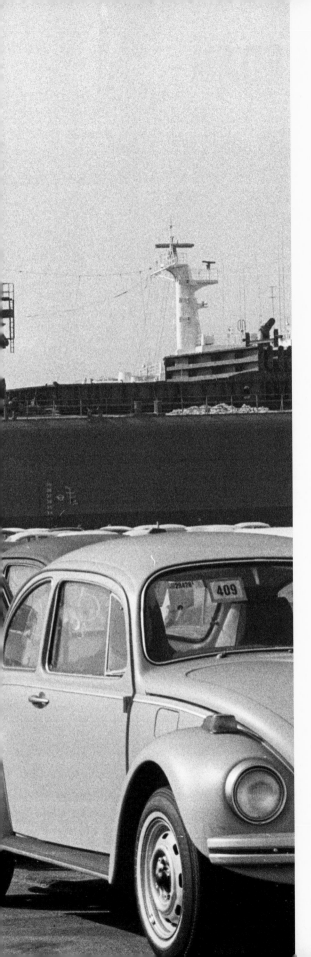

"A nation is no longer judged by the length of its railways but by the length of its highways," Adolf Hitler declared in a speech at the Berlin Motor Show in 1933. An admirer of Henry Ford as much for his innovations in assembly-line production as for his anti-Semitic proclivities, the newly installed chancellor envisioned Germany's future paved with asphalt and abounding with private automobiles. This plan required a car affordable to the middle and lower classes, for whom car ownership had up until then been a financial impossibility. Hitler tasked German automakers with producing a vehicle capable of accommodating four people and of reaching a speed of sixty-two miles per hour. This *Volkswagen*, or "people's car," would be priced below one thousand Reichsmarks—an unheard-of low sum equivalent to about eight thousand dollars today.

The result was the Volkswagen Type 1 Sedan, a 1,600-pound, steel-bodied vehicle designed by the automotive engineer Ferdinand Porsche that zipped along thanks to a twenty-five-horsepower, rear-mounted engine. Under the National Socialists' *Kraft durch Freude* (Strength through joy) propaganda campaign, which promoted travel and leisure activities for the masses, German citizens were encouraged to set aside funds for their very own "KdF-Wagen" through a state-sponsored savings scheme. That effort was halted as war preparations ramped up and the manufacture of Volkswagens was put on hold. It was only after World War II that production of the Type 1 escalated, swiftly positioning Germany as a global automotive powerhouse and significantly aiding the country's postwar economic recovery.

Better known today as the Beetle, the Type 1 went on to become the best-selling automobile of all time in 1972, surpassing Ford's Model T, which was the first mass-produced vehicle to achieve widespread popularity. In the intervening period the Beetle's bulbous, aerodynamically efficient form had remained virtually unchanged. Slight modifications—like swapping the early split rear windshield for a single glass panel in 1953—were hardly noticeable in the American auto market, where cars experienced stylistic changeover on a nearly yearly basis since the 1930s. Yet consumers continued to be drawn in by the Beetle's accessible price point and top-quality engineering. Clever advertising devised by Doyle Dane Bernbach, a New York–based firm hired by Volkswagen in 1959, celebrated the car's sturdy reliability and positioned it as a quirky alternative to the highly stylized American cars then in vogue. As at home in the countercultural revolutions of the 1960s as in the garages of the burgeoning postwar middle classes, the Beetle proved an enduring presence in the lives of millions around the globe. Even when production ceased in Europe and the United States in the 1970s, sales in Brazil and Mexico persisted until 2003, when the last Type 1 rolled off the assembly line in Puebla, Mexico.

—AG

Volkswagen Type 1 sedans unloaded from a ship at a
US marine terminal, September 23, 1969

VOLKSWAGEN TYPE I SEDAN

Designed 1938 (this example 1959)
Designer: **FERDINAND PORSCHE** (German, born Bohemia. 1875–1951)
Manufacturer: **VOLKSWAGENWERK AG** (Wolfsburg, West Germany, est. 1938)

Steel body with glass, rubber, and other materials
The Museum of Modern Art, New York. Acquired with
assistance from Volkswagen of America, Inc.
Conservation was made possible by a partnership
with Volkswagen of America, Inc.

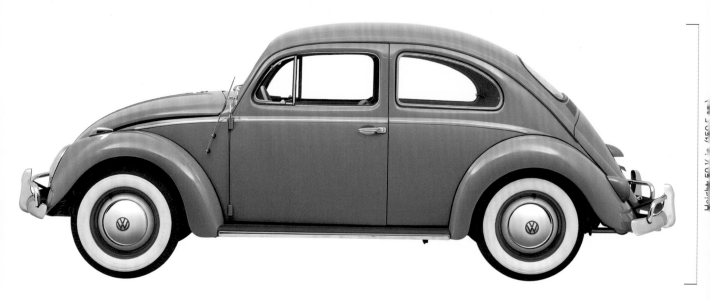

Length: 13 ft. 4 ½ in. (407.7 cm)

All-steel construction
improves safety

More than 21 million sold over
the six decades the car was in
production

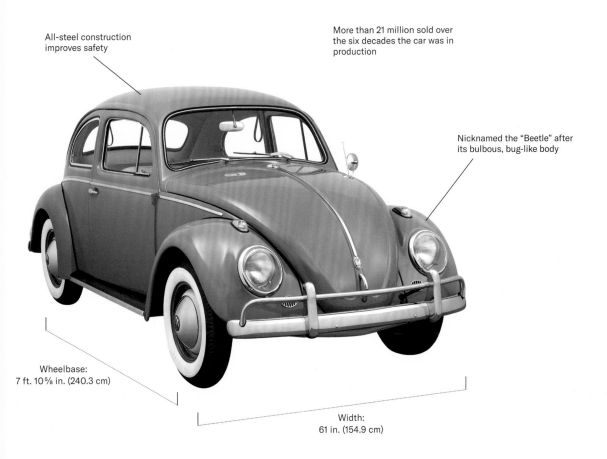

Nicknamed the "Beetle" after
its bulbous, bug-like body

Wheelbase:
7 ft. 10⅝ in. (240.3 cm)

Width:
61 in. (154.9 cm)

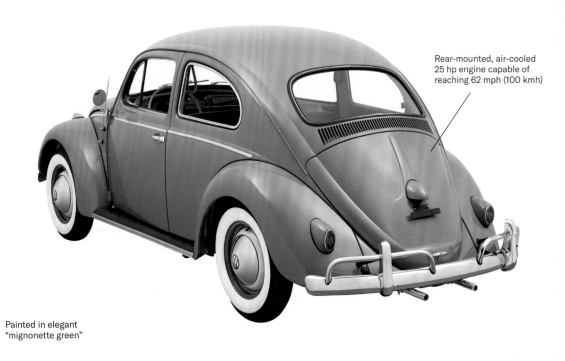

Rear-mounted, air-cooled
25 hp engine capable of
reaching 62 mph (100 kmh)

Painted in elegant
"mignonette green"

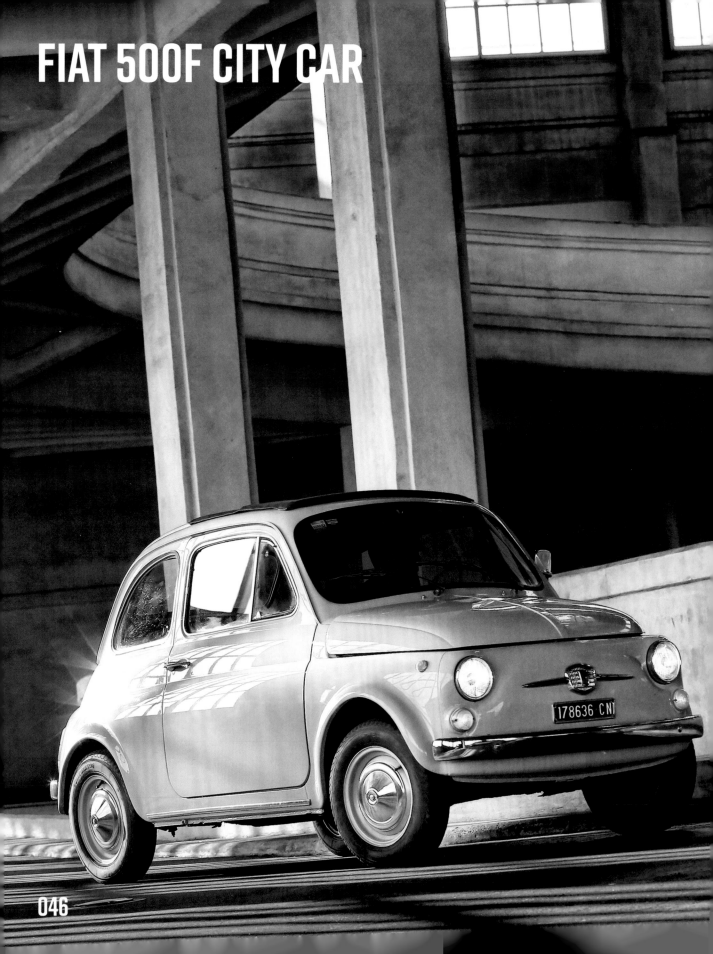

FIAT 500F CITY CAR

Italian automotive history is most often told through the flashy races (Mille Miglia, Targa Florio), luxury car manufacturers (Alfa Romeo, Maserati, Lamborghini), and colorful personalities (Enzo Ferrari, Battista "Pinin" Farina) that enrich the narrative. A more grounded version of the tale centers the industrial giant that, throughout the twentieth century, utterly dominated automobile production in the country: Fabbrica Italiana Automobili Torino. Established in 1899, Fiat became the largest automobile manufacturer in Italy within a decade of its founding—a distinction it has held ever since. In its early years, the company's massive Lingotto factory offered an updated interpretation of Henry Ford's assembly-line production model: raw materials entered on the ground floor, and production moved upward in the five-story building until the finished cars emerged onto the rooftop racetrack for testing. This innovative approach to aligning manufacturing techniques with architecture profoundly influenced modernist figures such as Le Corbusier, who illustrated the Lingotto factory in his polemical tract *Toward an Architecture* (1923). By the 1960s Fiat was an enormous conglomerate whose success mirrored Italy's ascent to one of Europe's leading industrial nations following the Second World War.

Commonly referred to as the Cinquecento, the Nuovo 500 was launched in 1957. This compact, rear-engine city car was a perfect fit not only for the tight streets of Italian towns but also for the needs of the burgeoning number of car owners. Conceived as an economical vehicle for the masses, the no-frills 500 was aimed at an Italian public that, while eager to embrace car ownership, remained financially limited. Fiat nailed its market precisely: the inexpensive Cinquecento proved an enormous hit, first in Italy and later throughout Continental Europe. Despite its diminutive exterior dimensions—it is more than three feet shorter in length than a Volkswagen Beetle—Dante Giacosa's clever design maximized interior volume, resulting in a surprisingly spacious cabin that could accommodate four passengers. The foldable fabric roof imbued the car with a sense of luxury while simultaneously reducing the amount of steel (a precious commodity at the time) necessary for production. In 1965 it was slightly redesigned, resulting in the discontinuation of the rear-hinged "suicide doors" that marked the original. The model in MoMA's collection, the 500f Berlina, was by far the best-selling version of the 500 and remained in production until 1973.

The humble Fiat 500 embodies many of the principles that guided mid-century modernist design: clear expression of a form that follows its function, logical and economical use of materials, and a belief that quality design should be accessible to all. The development of cheap, reliable cars like the Fiat 500 was instrumental in knitting together formerly disparate communities and nations across Europe and in fostering a feeling of freedom of movement throughout the continent. The Cinquecento's centrality to the story of postwar Europe, and to the story of Italy in particular, makes it an unforgettable icon of design.

—PG

MoMA's Fiat 500f City Car ("Cinquecento") ascending the rooftop racetrack at the Fiat Lingotto Factory, Turin, 2016

FIAT 500F CITY CAR

Designed 1957 (this example 1968)
Designer: **DANTE GIACOSA** (Italian, 1905–1996)
Manufacturer: **FIAT S.P.A.** (Turin, Italy, est. 1899)

Steel body with fabric top, glass, rubber, and other materials
The Museum of Modern Art, New York.
Gift of Fiat Chrysler Automobiles Heritage

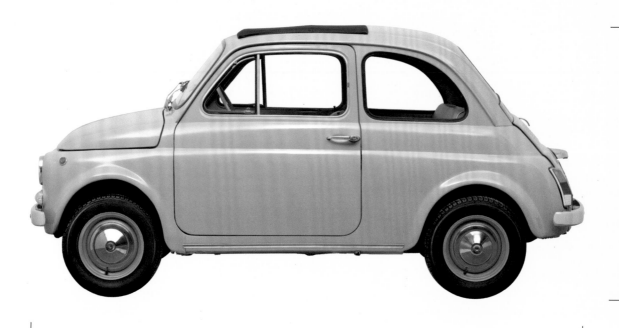

Height: 52 in. (132.1 cm)

Length: 9 ft. 8 ⅞ in. (296.9 cm)

Foldable fabric roof

Room for four
(small) people

More than 300,000
produced in 1968

Cost in 1968:
500,000 Italian lira,
or about 375 dollars

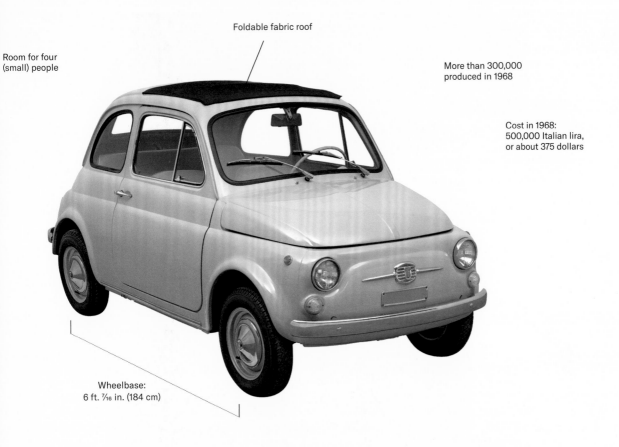

Wheelbase:
6 ft. 7/16 in. (184 cm)

Air-cooled 13 hp engine
capable of reaching
50 mph (80 kmh)

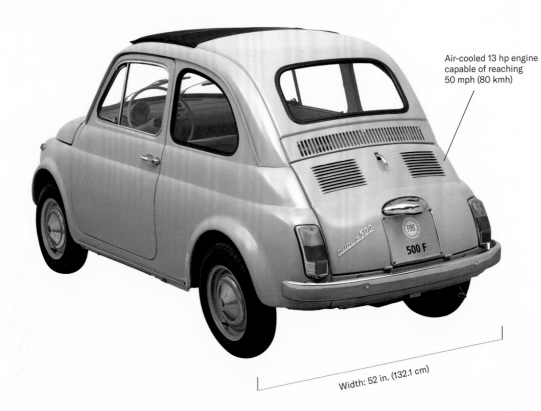

Width: 52 in. (132.1 cm)

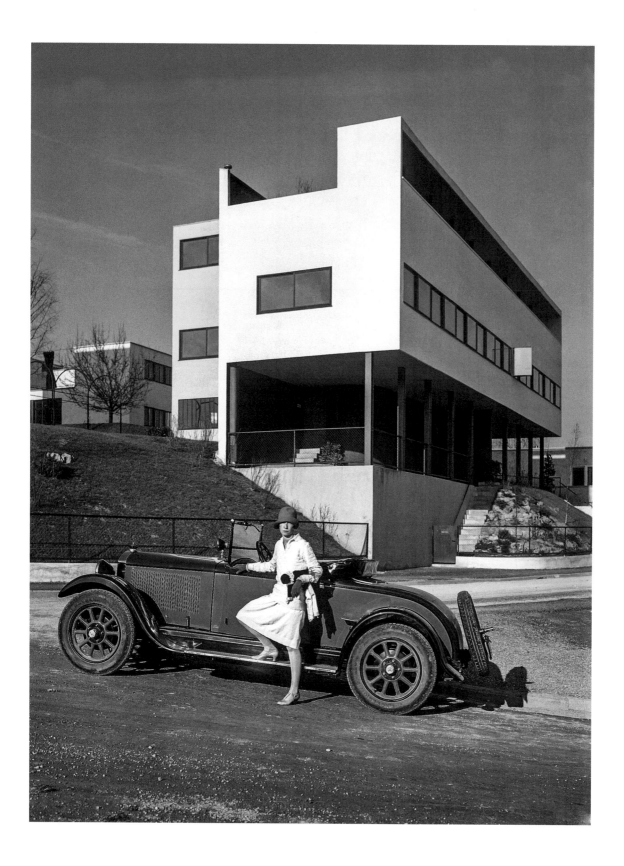

050 Advertising image for the Mercedes-Benz 8/38 PS Roadster, with Elsbeth Büchle, a teacher of dance and gymnastics, in front of Twin House, designed by Le Corbusier and Pierre Jeanneret, for the Weissenhof Estate, Stuttgart. 1927

3. DRIVING FORWARD: PIONEERS OF MODERNISM

For early modernists the automobile was an essential adjunct of modern living, epitomizing power, speed, and functionality (opposite). Between the two World Wars, not only the machine itself but the production processes and commercial display associated with it were fetishized by those of an avant-garde persuasion. If the automobile industry could mass-produce cars quickly, efficiently, and relatively cheaply, it was argued, why couldn't a similar system be applied to housing, kitchens, and clothing? In his polemical tract *Toward an Architecture* (1923), the Swiss-French architect Le Corbusier drew a connection across the centuries between a Delage Grand Sport, a marvel of modern engineering, and the ancient Greek Parthenon, the gold standard of classical art, as reflections of the needs and spirit of their respective eras (fig. 1). In 1924 the Polish artist and designer Henryk Berlewi eschewed conventional art galleries in favor of an automobile showroom in Warsaw as the setting for an exhibition of his Constructivist compositions (fig. 2). The expansive interior space and large glazed windows of such showrooms suited the display of modern art, particularly when the art in question—which Berlewi called his

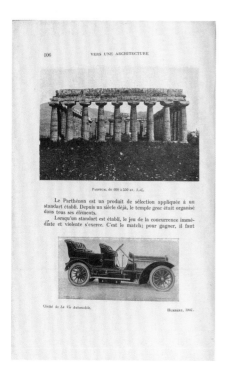

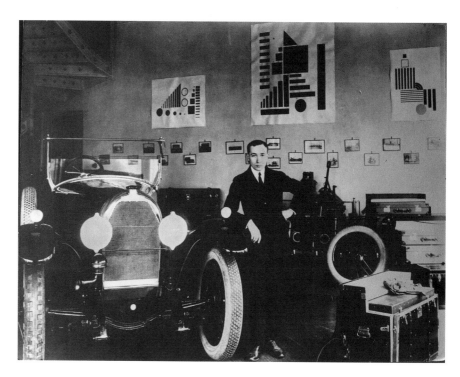

Mechano-Faktura—was inspired by the pumping rhythms, metallic precision, and standardized forms of the vehicles for sale. Architectural journals of the interwar years were strewn with references to automobiles as harbingers of aesthetic and socioeconomic transformation. According to Hannes Meyer, a future director of the Bauhaus school of art, architecture, and design, the car embodied the promise of new physical and imaginative freedoms: "Ford and Rolls-Royce have burst open the core of the town, obliterating distance and effacing the boundaries between town and country . . . Ford's motor sets free our place-bound senses."[1]

Design visionaries around the world—among them Eileen Gray and Le Corbusier in France, Dorothée Pullinger in Scotland, Walter Gropius in Germany, and Frank Lloyd Wright in the United States—were keenly aware of the mass-produced car's symbiotic relationship with modern architecture and design, a perception that stemmed from an almost obsessive fascination with the cars they each drove. In the 1920s Gray could often be seen driving around Paris in a convertible Chenard-Walcker, reportedly with the nightclub singer Damia, one of her lovers, and Damia's pet panther in the backseat. As the architect and critic Jean Badovici observed in 1924, Gray was "modern in every sense": "She understands that our times have brought, along with new ways of living, the need for new ways of feeling; the tremendous importance of mechanization could not fail to transform human sensibility."[2] Le Corbusier's car of choice was an expensive Voisin C14 Lumineuse, which appeared in numerous photographs of his completed works as a kind of stand-in for the architect himself and as an index of his commitment to standardization and modernity. Gropius delighted in the Adler Standard 6 of his own design, and Wright, perhaps the most fanatical car lover of them all, owned or rented eighty-five automobiles over his lifetime—the majority brought into the register of his design style with a coating of his signature Cherokee Red. The cars Wright himself designed in 1920 and 1956—like Le Corbusier's Voiture Minimum of 1935, conceived as a European answer to the Model T—were commercial non-starters that were never put into production.

1.
Le Corbusier (Charles-Édouard Jeanneret) (French, born Switzerland. 1887–1965)
Page 106 of *Vers une architecture* (*Toward an Architecture*). 1924
Published by G. Crès et Cie, Paris
The Museum of Modern Art Library, New York

2.
Henryk Berlewi at his first exhibition of abstract *Mechano-Faktura* drawings, in the Austro-Daimler showroom, Warsaw, 1924

Unusually for a woman, Gray could afford to own and drive her own car from an early age, buying her first in 1902. She soon became one of the first women in Paris to get a driver's license, and drove an ambulance during World War I. It was during this conflict that many women acquired a taste for cars as drivers and mechanics, including Pullinger, who after the war became the fir\ st female member of the British Institution of Automobile Engineers as well as the manager of Galloway Motors, a subsidiary of the Scottish automobile manufacturer Arrol-Johnston. Her company was unique in being staffed entirely by women, who were encouraged to undertake three-year engineering apprenticeships, and the Galloway cars they built were designed around the female physique. In 1924 Pullinger carried off the trophy for the Scottish Six Days Trial driving one of these cars, four thousand of which were manufactured before Galloway Motors folded in 1928. Elsewhere in the automobile industry, women were generally restricted to working on the upholstery and interior detailing of cars and labored anonymously even when, as in the case of Lilly Reich, they had established reputations in other fields of design. Reich was a teacher at the Bauhaus and a prominent member of the Deutsche Werkbund, an association of manufacturers and designers keen to promote the alliance of art and industry. In the 1930s she designed an ingenious folding car seat that exploited the lightness and strength of tubular steel (fig. 3). The textiles workshop at the Bauhaus—though dismissively referred to by Gropius, the school's founding director, as the "women's department"—produced some of the most experimental and industrially advanced work in the school, such as the range of fabric samples for automobile upholstery woven by Anni Albers (fig. 4). These probably date from around 1933, either shortly before or after she left Germany for the US. With an eye to their ultimate function, Albers created textural weaves from a combination of wiry horsehair, hard-wearing gimp yarn, and a bobbly chenille for extra comfort, using a subtle palette that would not easily show dirt.

Gropius worked for Adler, which was based in Frankfurt am Main, as a consultant, designer, and promoter from 1929 to 1932. Car design was a complex

3.
Lilly Reich (German, 1885–1947)
Design for tubular-steel folding car seat. 1930s
Pencil on tracing paper, 11 ¼ × 19 ⅝ in.
(28.6 × 49.8 cm)
The Museum of Modern Art, New York. Lilly Reich Collection, Mies van der Rohe Archive

4.
Anni Albers (American, born Germany. 1899–1994)
Automobile-upholstery fabric swatches. 1930s–40s
Top: horsehair and gimp, 2 ⅞ x 2 ⅝ in. (7.3 x 6.7 cm);
bottom: horsehair and chenille, 3 x 2 ⅝ in.
(7.6 x 6.7 cm)
The Museum of Modern Art, New York. Gift of Josef Albers

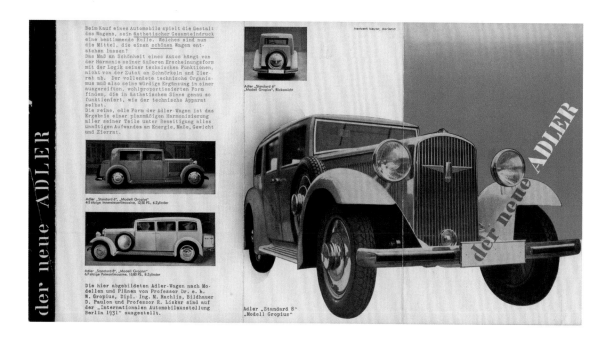

business involving many people. Yet despite only being responsible for the outer bodywork of Adler's new Standard 6 and 8 car models, Gropius garnered the lion's share of critical praise for their design.[3] He personally drove the new luxurious cabriolet version of the Standard 8 from Germany to Paris for its launch at the Salon de l'Automobile in 1930, which coincided with his organization of an influential exhibition of Deutsche Werkbund design in the French capital. The Adler project was in the spirit of his earlier Bauhaus program to create aesthetically pleasing, functional objects suitable for mass production. For Gropius and his Bauhaus acolytes, the beauty of these objects derived from the unity of form and function, as spelled out in a 1931 brochure advertising the Adler Standard 8 (fig. 5): "When buying a car, its shape and overall aesthetic impression play a decisive role. . . . The degree of a car's beauty depends on the harmony of its external appearance with the logic of its technical functions, not on the addition of flourishes and ornaments. The perfect technical organism must therefore find its worthy complement in a mature, well-proportioned form which, in an aesthetic sense, functions in exactly the same way as the technical apparatus itself." The look of the brochure underscored mechanical precision and rational objectivity, qualities that characterized the avant-garde New Typography movement then emerging in Central Europe. The design had been entrusted to Gropius's friend (and his wife's lover) Herbert Bayer, whom the architect had appointed to head the new printing and advertising workshop at the Bauhaus in 1925. Adler was a brand also known for its typewriters, a connection indirectly referenced by Bayer's use of typewritten script for the brochure.

The car-centric outlook of Le Corbusier and Frank Lloyd Wright extended to how they considered their role in shaping cities of the future and new patterns of work and leisure. At the end of the 1920s, Le Corbusier drew up a radical proposal for the redesign of Montevideo and São Paulo following a visit to South America in 1929 (fig. 6). Giant freeways dominate, cutting through the landscape into the heart of the city to unclog increasingly congested streets and separate speeding cars from pedestrians. The sketch for Montevideo, at the top of the

5.
Herbert Bayer (American, born Austria. 1900–1985)
Brochure for a car designed by Walter Gropius for the German car company Adler. 1931
Letterpress, 8 ¼ × 15 ⅝ in. (21 × 39.7 cm)
Printer: Dorland, Berlin
The Museum of Modern Art, New York.
Jan Tschichold Collection, Gift of Philip Johnson

drawing, highlights a giant business center under a motorway that juts into the bay, connecting the most important buildings and bypassing the preexisting urban chaos. The plan for São Paulo, below, attempts to dodge the city's traffic by suspending a cruciform arrangement of motorways on the roofs of residential apartment blocks.

Wright's view of the future was also structured around "giant roads, themselves great architecture."[4] In Broadacre City, a comprehensive plan for the urbanization of the American landscape that Wright worked on from the 1920s until his death in 1959, the architect imagined a web of roads that would connect urban and rural communities across the US. Traveling along the highway, a "horizontal line of Freedom extending from ocean to ocean, tying woods, streams, mountains, and plains together,"[5] the automobile would become an agent of diffusion and cohesion. Distributed along a rectilinear grid, single family homesteads were to be combined with small-scale manufacturing and community centers linked by a system of roads "so that each citizen . . . will have all the forms of production, distribution, self-improvement, enjoyment, within a radius of a hundred and fifty miles of his home now easily and speedily available by means of his car."[6] New kinds of roadside architecture would assist the disaggregation of commerce and industry from the city and make mobilization a pleasure, not a nuisance.[7] Motorized transport would also transform agriculture and the food industry, with roadside markets offering newly mobile consumers fresh, locally sourced food. These ideas were manifested in Wright's book *The Living City* (1958), the culmination of his Broadacre City project, which included an illustration of a futuristic cityscape encircled by freeways populated with "road machines," a car whose design was partly inspired by a tractor (fig. 7).

In 1924 Wright was commissioned by Gordon Strong, a Chicago-based real estate entrepreneur, to design a structure for the summit of Sugarloaf Mountain in Maryland as a destination for motor trips from Baltimore and Washington, DC. Referred to by the architect as an "automobile objective," the concept was ultimately never realized. In preliminary sketches, a ziggurat form,

6.
Le Corbusier (Charles-Édouard Jeanneret)
(French, born Switzerland. 1887–1965)
Urban projects for Montevideo and São Paulo.
Aerial perspectives. 1929
Ink on paper, 10 ⅝ × 6 ½ in. (27 × 16.5 cm)
The Museum of Modern Art, New York.
Emilio Ambasz Fund

7.
Frank Lloyd Wright (American, 1867–1959)
The Living City Project. 1958
Pencil and ink on paper, 33 ½ × 42 ⅛ in.
(85.1 × 107 cm)
The Frank Lloyd Wright Foundation Archives
(The Museum of Modern Art | Avery Architectural
& Fine Arts Library, Columbia University,
New York)

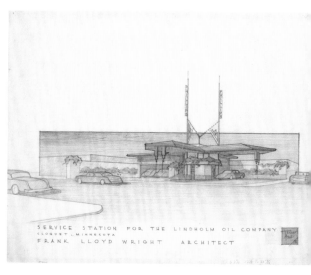

one of the classic building types associated with Indigenous societies of the pre-Columbian Americas, appears to grow organically from the land (fig. 8). Sitting comfortably in their cars, visitors would ascend a spiral ramp with the whole landscape revolving around them—a new viewing paradigm in which the car's windshield functions as a cinematic screen.

Wright saw the humble gasoline service station, although a generally ugly and insignificant type of roadside architecture, as having an important role to play in the processes of decentralization. He envisaged such stations as social hubs with the potential to grow into convenient neighborhood distribution centers. Developed from a design originally conceived in 1932 as part of Wright's Broadacre City, the Lindholm Oil Company Service Station in Cloquet, Minnesota, completed in 1957, is indicative of the architect's desire to elevate and modernize service station design (fig. 9). Glazed service-bay doors and skylights in a second-floor leisure space for customers dissolve the distinction between inside and outside, and the Cherokee Red floor and accents of mahogany and copper offset the station's otherwise plain concrete-block core.

In *Modern Architecture: International Exhibition* (1932), MoMA's landmark survey of international modernist architecture, a Standard Oil Company filling station in Cleveland, Ohio, was one of the few examples representing American modernism. It was also the filling station to which the arts impresario Lincoln Kirstein turned for the scenario of a one-act ballet (matter-of-factly titled *Filling Station*) premiered by Ballet Caravan in Hartford, Connecticut, in 1937. Featuring a score by Virgil Thomson and sets and costumes by Paul Cadmus (figs. 10, 11), the ballet dramatized the interactions between a transient cross-section of society that passes through the service station. As predicted by Picabia in 1915 (see page 32), the American passion for all things car-related had begun to generate a quintessentially American brand of modern art.

8.
Frank Lloyd Wright (American, 1867–1959)
Gordon Strong Automobile Objective and Planetarium Project, Sugarloaf Mountain, Maryland. 1924–25
Pencil and colored pencil on tracing paper, 19 ¾ × 30 ¾ in. (50.2 × 78.1 cm)
The Frank Lloyd Wright Foundation Archives (The Museum of Modern Art | Avery Architectural & Fine Arts Library, Columbia University, New York)

9.
Frank Lloyd Wright (American, 1867–1959)
Lindholm Gas Station, Cloquet, Minnesota. 1956
Pencil and colored pencil on tracing paper, 18 × 22 ¾ in. (45.7 × 57.8 cm)
The Frank Lloyd Wright Foundation Archives (The Museum of Modern Art | Avery Architectural & Fine Arts Library, Columbia University, New York)

1 Hannes Meyer, "Die neue Welt," *Das Werk* 13, no. 7 (1926): 222.

2 Jean Badovici, "L'Art de Eileen Gray," *Wendingen* 6, no. 6 (1924): 12.

3 One has to look in the small print of the brochure advertising the Standard 8 for the names of the engineers and modeler: Michael Rachliss, D. Paulin, and Professor R. Lisker. Although Gropius's design was widely and favorably reviewed, it appears that only six Standard 8s were actually built.

4 Frank Lloyd Wright, *The Disappearing City* (New York: William Farquhar Payson, 1932), 44.

5 Wright, *An Autobiography* (London: Faber and Faber, 1946), 326.

6 Wright, *The Disappearing City*, 44.

7 See Wright, "The City," in *Modern Architecture: Being the Kahn Lectures for 1930* (Princeton, NJ: Princeton University Press, 1931), 101–15.

10.
Paul Cadmus (American, 1904–1999)
The Motorist. Costume design for the ballet *Filling Station* (recto shown). 1937
Gouache, watercolor, pencil, and pinned fabric on paper (recto), 11 ⅛ × 10 in. (28.3 × 25.4 cm)
The Museum of Modern Art, New York. Gift of Lincoln Kirstein

11.
Paul Cadmus (American, 1904–1999)
Set design for the ballet *Filling Station*. 1937
Cut-and-pasted paper, gouache, watercolor, and pencil on paper, 8 × 10 ⅞ in. (20.3 × 27.6 cm)
The Museum of Modern Art, New York. Gift of Lincoln Kirstein

CISITALIA 202 GT CAR

When the Cisitalia 202 GT made its debut at the 1947 Salon de l'Automobile in Paris, it represented a dramatic meeting point of the past and the future. From manufacturing techniques linking it to the horse-drawn-carriage tradition to Pininfarina's radical sculptural form, which influenced sports car design for decades after, the 202 reflects the developments that shaped car design in the first half of the twentieth century.

Founded in 1946, Cisitalia (Compagnia Industriale Sportiva Italia) was an Italian company dedicated to producing racing cars. The 202, of which just 170 were produced, was the first and only Cisitalia car to be built for commercial use. As was standard practice at the time, Cisitalia did not make its cars from scratch: the chassis, engine, and other components were sourced from vehicles produced by other manufacturers. The 202's components came from the commonplace Fiat 1100 family car. Upon this foundation Cisitalia laid a custom body in a process known as "coachbuilding." Before the advent of mass manufacturing, all car parts were handmade, and many of the craftsmen who constructed early cars came from the horse-carriage trade. Unlike the machine-stamped body panels of the Ford Model T, for instance, the 202 and other coach-built cars featured bodies hammered out by hand on wooden frames. Despite these primitive-seeming production methods, the Cisitalia offers a compelling example of masterful industrial design.

The exterior shape of the 202 was determined by Battista "Pinin" Farina, who holds a near-mythic place in the history of Italian car design. Pininfarina (as he would later call himself) started his own coachbuilding firm in 1928, producing cars for Fiat, Lancia, Alfa Romeo, and many others before working with Cisitalia. His design for the 202 eliminated the separate body panels and ornamentation common to cars of the period in favor of a unified structural skin, or monocoque. Headlights are incorporated into the front fenders, which seamlessly combine with the hood. The car's entire shape flows backward in gentle swells, illustrating the principles of aerodynamics. The taught, biomorphic aluminum skin of the 202 seems formed by nature rather than by human hands.

Because the body of the Cisitalia 202 was handmade, manufacturing time was slow, leading to delays in delivery. These setbacks, combined with the car's high production cost and weak engine, doomed the 202—and, with it, the company. Although the 202, which was discontinued after 1952, was a disappointment from an economic perspective, its elegant exterior ensured its status within the design canon. It was featured at MoMA in the 1951 exhibition *8 Automobiles*, the first automobile show ever presented at an art museum. Perhaps no car in the show better embodied the curator Arthur Drexler's characterization of cars as "hollow, rolling sculpture" than the 202, with Cisitalia's decidedly artistic approach to shaping the form of an automobile.

—PG

A restored 1949 Cisitalia 202 Gran Sport in the Swiss Alps, c. 2013

CISITALIA 202 GT CAR

Designed 1946 (this example 1948)
Designer: **PININFARINA** (**BATTISTA "PININ" FARINA**) (Italian, 1893–1966)
Manufacturer: **S.P.A. CARROZZERIA PININFARINA** (Turin, Italy)

Aluminum body with glass, rubber, and other materials
The Museum of Modern Art, New York.
Gift of the manufacturer

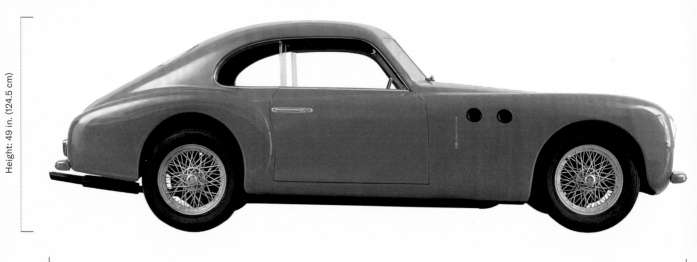

Height: 49 in. (124.5 cm)

Length: 12 ft. 5 in. (378.5 cm)

Cisitalia 202 GT. Photograph by Alexandre Georges, reproduced in the catalogue for the exhibition *8 Automobiles*, The Museum of Modern Art, New York, August 28–November 11, 1951. MoMA Archives, New York

First car acquired by
MoMA, in 1972

Only 170 produced

Hand-formed body panels

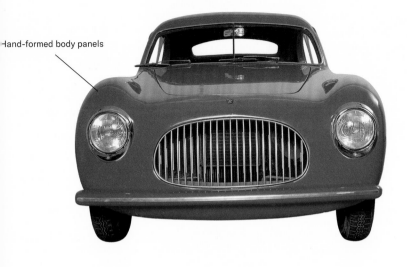

Width: 58 in. (147.3 cm)

4-cylinder 60 hp engine capable
of reaching 97 mph (156 kmh)

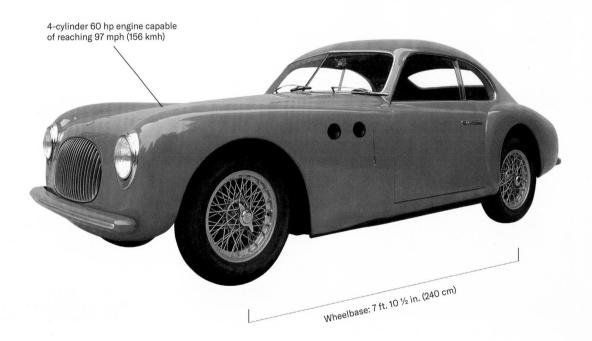

Wheelbase: 7 ft. 10 ½ in. (240 cm)

General Motors Motorama, Waldorf Astoria Hotel, New York, with the GM Firebird I concept vehicle (center),
Cadillac four-door sedan (back right), and Buick Wildcat II concept vehicle (front right), 1954

4. THE LOOK OF THINGS

Rationing and postwar reconstruction maintained a hold on Europe well into the 1950s, inhibiting the expansion of the domestic market for cars, which were still viewed as a luxury rather than a necessity. Although a number of affordable, compact cars such as the Fiat 500 (see pages 46–49) and the Morris Minor were under development, European manufacturers remained focused, for the most part, on small-run production for a relatively exclusive and wealthy clientele. In the United States, by contrast, the mass market for automobiles established in the 1930s was booming, with the hundred-millionth passenger car rolling off the stocks in December 1951. In an intensely competitive landscape, American manufacturers introduced annually updated models, color ranges, and spectacular events to whet consumers' appetites, leading to what Raymond Loewy described as an "orgiastic chrome-plated brawl."[1] One of the most influential industrial designers of the twentieth century, Loewy lamented that the lineup of new models in 1955 gave an impression of Americans as "wasteful, swaggering, insensitive people."[2] Passing judgment on a new crop of cars had become like passing judgment on a nation's soul, with discussions around the aesthetics of car design and planned obsolescence hinting at a spiritual chasm opening up between Europe and the

1.
General Motors Motorama, Miami, with the GM
Firebird II show car, 1956

US, and between the design establishment—represented in the US by MoMA—
and American commercial automakers. The Museum waded into the fraught
polemics around car styling with a symposium on the subject organized by Philip
Johnson, the director of the Department of Architecture and Design, in 1950.
The symposium was followed by the landmark exhibition *8 Automobiles* in 1951,
and its second iteration, *Ten Automobiles*, in 1953; both shows were curated
by Arthur Drexler, who was inclined toward the more restrained and sculptural
aesthetics of European car design, and who would succeed Johnson as head
of MoMA's architecture and design department in 1956. With these exhibitions
came artistic validation for certain automobile makers, but only insofar as their
cars were seen to transcend the vagaries of fashion and measure up to the "good
design" principles advocated by MoMA since the 1930s—in other words, as use-
ful, undecorated objects suited to modern living, using materials and technolo-
gies "of our time."

 While the Museum's mid-century foray into exhibiting and writing about
automobiles attracted attention in the press, it was undoubtedly upstaged
by the ways in which Detroit's Big Three—General Motors, Ford, and Chrysler—
presented cars to the general public (fig. 1). From 1949 to 1961 General Motors—
the largest industrial manufacturer in the world, with staggering sales in 1953 of
more than ten billion dollars—organized a series of crowd-pleasing multimedia
extravaganzas known as "Motoramas" at the Waldorf Astoria hotel in New York, on
the doorstep of The Museum of Modern Art (see page 62). The new and futuristic
cars on the 1953 catwalk were accompanied by elegant models wearing "fashion
firsts" that matched the automobiles and had been commissioned from leading
designers, such as Pauline Trigère and Christian Dior. Infotainment in the form of
film screenings, ballet, and live music carried onlookers toward "the promise of
tomorrow."[3] Yet despite GM's overwhelming popularity among American consum-
ers, the auto giant's cars were notably absent from either of MoMA's automobile
exhibitions. American mass-produced cars, it seems, did not meet the Museum's
criteria for "excellence as works of art" and "relevance to contemporary problems

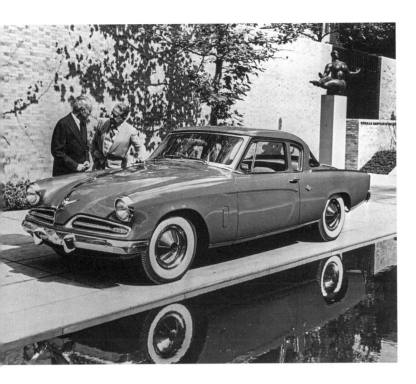

of passenger car design."[4] On the contrary, according to MoMA's automobile con-
sultant, John Wheelock Freeman, the frequent comparisons between such cars
and "juke boxes or the boudoirs of ill-famed women seem to bear out the idea
that our cars lack restraint and taste."[5] Three of the eight vehicles Freeman helped
select for the 1951 show were American, but two were limited-run luxury cars
(a Cord and Lincoln Continental) and the other was a military vehicle, the Jeep
(see pages 18–21). In 1953 the only American-designed and made car to make the
grade for *Ten Automobiles* was a Studebaker Commander V-8 Starliner Coupe
designed by Raymond Loewy and Associates (fig. 2), which Drexler praised as "the
first American mass-produced car to adapt the design characteristics of European
automobiles."[6] The presentation of the cars in MoMA's garden was correspond-
ingly subdued, deliberately eschewing the razzmatazz of a GM Motorama. As
Drexler wrote in the *8 Automobiles* catalogue, "An automobile is not a shop win-
dow or a new dress, however much it may be influenced by fashion."

Chosen to complement the "sober, unaffected design" of the cars on
display, the catalogue cover of *8 Automobiles* showed the "carefully groomed"
exterior of a British Bentley exuding what Drexler termed "a patrician urbanity
of style" (see page 8). The photograph of a single unadorned wheel hub from the
Studebaker Starliner, dramatically isolated against a white ground, adorned the
cover of *Ten Automobiles* (fig. 3). This image gave a visual nod to the self-aligning
ball bearing selected by Bauhausler Josef Albers for the cover of the catalogue
for *Machine Art* (1934). MoMA's first exhibition of industrial design, *Machine Art*
challenged visitors to give everyday objects, ranging from a saucepan to an air-
plane propeller, a second look. In the intervening period the Museum had made
consistent efforts to promote the better understanding of well-designed con-
temporary products. Two exhibition series, Useful Objects (1938–48) and Good
Design (1950–55), showcased products selected on the basis of eye appeal,
functionality, construction, and price—criteria that could also be extended to
automobiles. In the words of Philip Johnson, "An automobile is a familiar
20th-century artefact no less worthy of being judged for its visual appeal than

4.
Gioacchino Colombo (Italian, 1903–1988)
Ferrari 125, cross section. 1945
Color pencil, graphite, and ink on buff
(pigmented or toned) woven paper, 12 5/8 × 32 11/16 in.
(32 × 83 cm)
Collection of Jon Shirley

a building or a chair."[7] His colleague Edgar Kaufmann, Jr., the director of the Good Design program, felt it was up to the Museum "to assume the responsibility of guiding the consumer toward those qualities which make an object beloved for generations."[8]

Both of MoMA's car exhibitions valorized Italian design—a prime example being the flawless envelope body of the Cisitalia 202 (see pages 58–61)—reflecting the organizers' belief that "in Europe, where a car is a luxury rather than a necessity, design still has some of the qualities of a fine art."[9] The 202 that featured in both shows was lent by John Wheelock Freeman, a European sports car enthusiast who had driven a British MG, V-12 Lagonda, and Bentley while still a student at Yale University (he later progressed from the Cisitalia to a German Porsche). His best-selling book *Sports Car Album* (1953), which sold 125,000 copies, emphasized the broad emotional appeal of sports-car principles and their applicability to passenger-car design. Of the companies Freeman profiled a considerable portion were Italian, such as Ferrari, then already one of the foremost makers of sports cars. Initially established by Enzo Ferrari to give himself a competitive edge on the racetrack, the small manufacturing outfit put out its first car, the Ferrari 125 S, in 1947, which combined sculptural styling with ergonomic and aerodynamic research, mechanical ingenuity, and technological innovation (fig. 4). The influence of such cars' sophisticated engineering and sleek body forms was felt on both sides of the Atlantic well into the 1950s, as indicated by the rounded profiles on the poster for the 1955 Salone Internazionale dell'Automobile in Turin (fig. 5).

In his discussion of *8 Automobiles* in the magazine *Auto Sport Review*, Freeman posed a frequently asked and apparently intractable question: "Can a really 'good' design sell large numbers when the public seems to prefer chrome-slathered bath-tubs?"[10] One of the "culprits" behind this American trend that he and Drexler identified was the stylist—a new kind of creative person who had appeared on the industrial scene, taking his place alongside the engineer, production expert, and scientist, and who now reigned supreme in the large

corporations. Harley Earl, the founding head of General Motors' Art and Color Section (later known as the Styling Section) realized early on that the aesthetics of body-styling were an integral part of the battle for margins. He led the industry's widespread adoption of a constantly evolving design language, pioneering a multistage process still practiced by automakers today. First, the Styling Section was responsible for creating a detailed design for each vehicle from the ground up, a process that began with a pencil and paper. Once preliminary sketches were resolved, full-size two-dimensional renderings of the car interior were produced. "One of the most useful people around an interior styling studio is a swivel-jointed fellow by the name of Oscar," wrote Henry B. Lent in *The Look of Cars: Yesterday, Today, Tomorrow*.[11] A life-size plexiglass figure with a brimmed hat, Oscar was placed on top of the drawings to help designers envision how an "average" 167-pound male body might fit in the car seats in relation to the roof, steering wheel, brake pedal, and other controls (fig. 6). Once the configuration of a car's various elements was determined, fully detailed renderings were generated, from which a clay model could be sculpted in three dimensions. Oscar had no female equivalent, despite American market research in 1953 estimating that women drove in 60 percent of car-owning families and were a dominant factor in 80 percent of all car purchases.[12] Aware of this market, Earl made a great play on the fact that he was recruiting women industrial designers from Brooklyn's Pratt Institute to join GM's Styling Section—a group the company's public relations arm dubbed the "Damsels of Design" (fig. 7). The "damsels"—a tokenizing moniker the designers resented—added many features that were to become industry standards, like childproof doors, lighted makeup mirrors, retractable seat belts, and storage consoles. Around the same time that these women had begun working for GM, McKinley Thompson, Jr., became the first African American car stylist to be hired at Ford. Thompson had first come to the company's attention in 1953, when his winning submission to a design competition organized by *Motor Trend* magazine earned him a Ford-sponsored scholarship to the Art Center College of Design in Pasadena, California. In his subsequent career at Ford,

5.
Armando Testa (Italian, 1917–1992)
Poster for the 37th Salone Internazionale dell' Automobile, Turin, Italy. 1955
Lithograph, 54 ¼ × 38 in. (137.8 × 96.5 cm)
The Museum of Modern Art, New York. Gift of the designer

6.
General Motors Corporation (United States, est. 1908)
"Oscar" anthropometric design template used by designers in the GM Styling Section. 1950s
Plastic and metal, approx. 45 ⁹⁄₁₆ × 49 ⅞ in. (115.7 × 126.7 cm)
The Museum of Modern Art, New York. Committee on Architecture and Design Funds

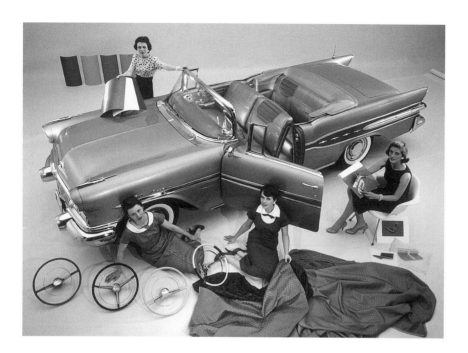

Thompson worked on several of the Thunderbird models and the "Warrior," his concept for an affordable, lightweight plastic vehicle intended for use in developing countries.

A contemporary of Harley Earl, Raymond Loewy first began providing creative direction to Studebaker in the 1930s, contributing to the company's reputation for bold, unique styling; in addition to the Starliner exhibited at MoMA, some of the most striking Studebaker designs he worked on included the Wagonaire Station Wagon and Avanti Coupe, both introduced in 1963. The concept sketches for these cars were handled by Tom Kellogg (fig. 8), then a student at the Art Center College of Design, Thompson's alma mater. The "Continental look" of the Studebaker Starliner had given way to a more sharp-edged car body in tune with 1960s fashion but still without encumbrances. Brooks Stevens, an industrial design icon his own right, engineered the retractable sliding rear roof section of the Wagonaire that allowed the vehicle to carry taller items than other, more conventional station wagons. Although the capacious, low, and streamlined body was instantly recognizable as American, the car's reduced weight and well-tuned six-cylinder engine, which aided with gas economy, distinguished it from its competitors. Despite the involvement of many others in specific roles, Loewy's name was a selling point that invariably took precedence in publicity campaigns around the Wagonaire and Avanti. Yet neither the designs themselves nor Loewy's repute were enough to turn around Studebaker, which folded in 1966, joining the long list of casualties in this cutthroat industry.

7.
General Motors' "Damsels of Design," with the 1957 Pontiac Star Chief convertible and prototype interior. Top: Gere Kavanaugh. Bottom, left to right: Dagmar Arnold, Peggy Sauer, and Jan Krebs

1

1 Raymond Loewy, "Jukebox on Wheels," *Atlantic Monthly*, April 1955, 36.

2 Ibid., 38.

3 General Motors, *Motorama Moods* (1953), promotional film; available on YouTube.

4 Arthur Drexler, *8 Automobiles*, exh. cat. (New York: The Museum of Modern Art, 1951), [3].

5 John Wheelock Freeman, "What Is Good Design?" *Auto Sport Review*, July 1952, 50.

6 Drexler, *Ten Automobiles*, exh. cat. (New York: The Museum of Modern Art, 1953), 10.

7 The Museum of Modern Art, New York, "Museum to Open First Exhibition Anywhere of Automobiles Selected for Design," press release no. 510823-46, August 23, 1951.

8 Edgar Kaufmann, Jr., "Museums Point the Way Home," *New York Times*, September 24, 1950.

9 Freeman, 8.

10 Ibid.

11 Henry B. Lent, *The Look of Cars: Yesterday, Today, Tomorrow* (New York: E. P. Dutton, 1966), 64–65.

12 "It's a Man's World . . . but women run it," *Challenge* 1, no. 10 (July 1953): 24–25.

8.
Raymond Loewy and Associates (United States, est. 1944)
Studebaker Wagonaire Station Wagon. Presentation drawing. 1963
Gouache, colored pencil, and graphite on paper, 14 × 27 ¼ in. (35.6 × 69.2 cm)
The Museum of Modern Art, New York. Gift of Jo Carole and Ronald S. Lauder

FERRARI FORMULA 1 RACING CAR 641/2

F ew machines are as regularly pushed to the ultimate limits of their engineering as are Formula 1 racing cars. Like fighter jets, rockets, and deep-sea submersibles, these cars face the formidable and myriad challenges of enabling human travel at speeds and in conditions inhospitable to survival. The pioneering work of designers and technicians in these industries has yielded countless technological advances that have found their way to more mundane applications in passenger aircraft, personal computers, and commercial automobiles.

One of the most storied racing car manufacturers, Ferrari has been at the forefront of innovation since its humble beginnings in the 1920s. Its founder, Enzo Ferrari, was a racing car driver himself before turning to producing cars for both professional competitions and everyday use. But racing was always Ferrari's main focus, dictating the direction of the company for decades. Produced shortly after Enzo's death, the 1990 Ferrari Formula 1 641 represents a pinnacle of the company's legacy.

Everything about the Ferrari 641—from its shape to its engineering to its materials—is determined by one overriding goal: speed. Capable of traveling well in excess of two hundred miles per hour, the 641 confronts aerodynamic challenges similar to those faced by aircraft and offers similar solutions. The bulbous body is designed to flow through the wind while the wings at the front and rear wheels produce downforce that ensures the car remains glued to the road, greatly enhancing the speed at which it can take turns. Weight is reduced wherever possible through the use of strong yet lightweight materials, such as aluminum, titanium, and carbon fiber. One particularly notable innovation is the computer-controlled gearbox, first introduced in the 1989 Ferrari 640 and significantly improved on in this model. Operated by levers placed behind the steering wheel, this gearbox eliminates the need for a stick shift and clutch. This novel approach to shifting increases both safety (by keeping the driver's hands on the wheel) and speed, resulting in as much as a one second advantage per lap. Today these "paddle shifters" are a common feature of passenger cars. For a machine of such technological complexity, the 641 is, paradoxically, an example of handmade construction. In an era in which the majority of car manufacturing is done by robots, John Barnard's design for Ferrari produces an extraordinarily unique, bespoke creation.

Formula 1 cars do not last—indeed are not *intended* to last—beyond a few races. Their engines must be completely rebuilt after only a few hundred miles, tires rapidly wear out and are replaced several times during a single race, and their exceedingly light bodies are destroyed by the most minor of crashes. "When at the end of a Grand Prix race, a constructor dismantles a car that has won a place and finds its components at the limit of their endurance through wear and tear," Enzo Ferrari wrote, "then may he truly claim that he has followed the new formula and followed it indeed to the limit of human foresight and endeavor."

—PG

FERRARI FORMULA 1 RACING CAR 641/2

Designed 1990 (this example 1990)
Designer: **JOHN BARNARD** (British, born 1946)
Manufacturer: **FERRARI S.P.A.** (Maranello, Italy, est. 1929)

Honeycomb composite body with carbon fibers, Kevlar, and other materials
The Museum of Modern Art, New York. Gift of the manufacturer

Wing creates
stabilizing downforce

Single wheel nut facilitates
rapid tire changes during
races

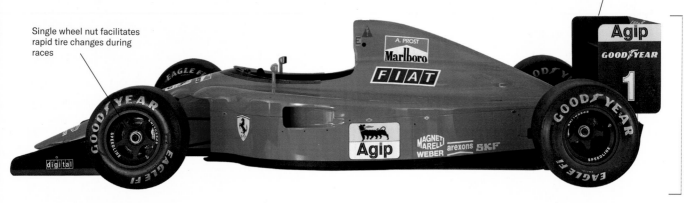

Height: 39 ⅜ in. (100 cm)

Length: 14 ft. 7 ⅝ in. (446.1 cm)

John Barnard (British, born 1946)
Body joints for Formula 1 Car, model no. 639. Sketch. 1987
Pencil on paper, 11 ¾ x 16 ⅝ in. (29.8 x 42.3 cm)
The Museum of Modern Art, New York. Gift of the designer

First car to feature
paddle shifters

680 hp engine capable of
reaching 215 mph (346 kmh)

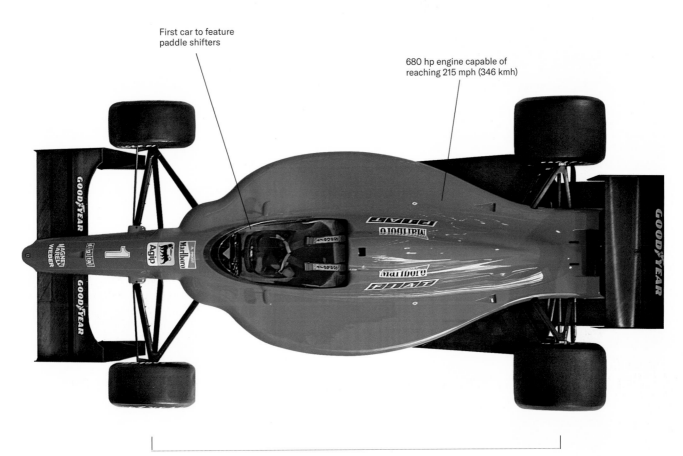

Wheelbase: 9 ft. 4 7/16 in. (285.6 cm)

Curb weight: 1,108 lb. (503 kg)

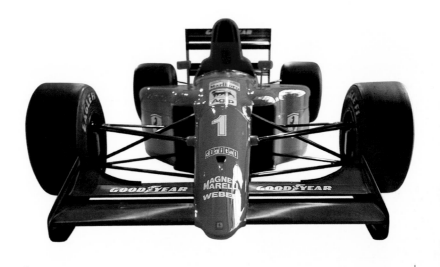

Width: 6 ft. 11 7/8 in. (213 cm)

PORSCHE 911 COUPÉ

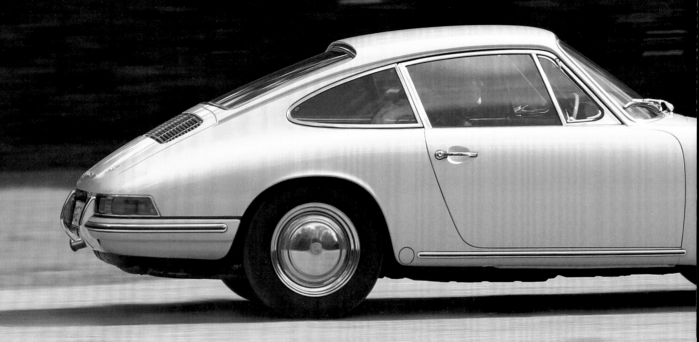

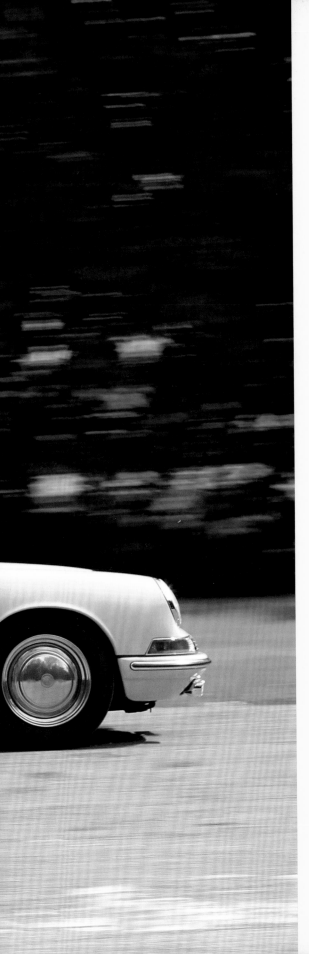

In the long history of automotive design, few family names rival that of Porsche. The company was founded in Stuttgart in 1931 by Ferdinand Porsche, who a few years later was contracted by the German government to design a *Volkswagen*, or "people's car" (see pages 42–45). Ferdinand's legendary Type 1 Sedan—colloquially known as the Beetle—went on to become one of the most popular cars of all time. After World War II Porsche AG started producing its own automobiles, aiming for a luxury market with the sporty 356, which was designed by Ferdinand's son, Ferry Porsche. Ferdinand's grandson, Butzi Porsche, continued the family legacy when he began designing the next evolution of the Porsche sports car in 1959: the 911.

First unveiled at the Frankfurt Motor Show in 1963 (when it was briefly designated the 901), the 911 is the most iconic vehicle to be produced by Porsche. Larger and significantly faster than its predecessor, the 356, the original 911 is a low-slung coupé with an air-cooled rear engine. Combined with the rear-wheel drive, the placement of the engine creates downward force on the back wheels, increasing traction. Round headlights are seamlessly incorporated in raised fenders, which, along with the sharply raked hood, taper dramatically to the tail end of the car. Although the DNA for the look of the 911 is clearly visible in the Volkswagen Beetle and Porsche 356, the integration of racing engineering—most notably a far more formidable engine—distinguishes the 911 from these earlier efforts. Butzi's design has proved timeless, serving as the basic template for subsequent iterations of the 911 for decades.

The history of racing-inspired motoring cannot be written without the inclusion of the 911, which dominated on the track. Indeed, if one includes its many variants, the 911 is the most successful competition car ever made. This evocation of speed was alluring to continental Europeans looking to drive something close to what they saw in races. For those who could afford it, the 911 offered a sensual experience. Embodying the raw power of technology, a sleek, throaty-voiced 911 gliding down the autobahn illustrated the capacity of design to create wholly new sensory experiences. Moreover, the Porsche 911 (as well as its cousin the Volkswagen Beetle) epitomized the postwar German *Wirtschaftswunder*, or "economic miracle," during which the country not only recovered from the destruction of the war but prospered, largely on the strength of a manufacturing renaissance. In its unique synthesis of high-tech engineering and a refined aesthetic, the Porsche 911 represents one of the great achievements of twentieth-century design.

—PG

PORSCHE 911 COUPÉ

Designed 1963 (this example 1965)
Designer: **F. A. "BUTZI" PORSCHE** (German, born Bohemia. 1935–2012)
Manufacturer: **PORSCHE AG** (Stuttgart, Germany, est. 1931)

Steel body with glass, rubber, and other materials
The Museum of Modern Art, New York.
Gift of Thomas and Glwadys Seydoux

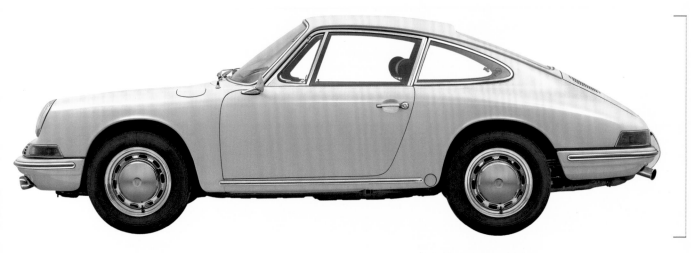

Height: 51 ½ in. (130.8 cm)

Length: 13 ft. 7 in. (414 cm)

3,389 produced in 1965

Rear-mounted engine improves
car's traction and acceleration

Model in MoMA's collection
features original interior

5-speed manual transmission

6-cylinder, 130 hp engine

Wheelbase:
7 ft. 2 ¼ in. (219.1 cm)

Width:
66 in. (167.6 cm)

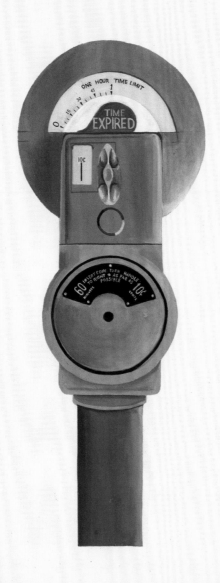

TIME EXPIRED

078　Vern Blosum (American, 1936–2017).
Time Expired. 1962
Oil on canvas. 37 ½ × 27 ⅞ in. (95.1 × 70.7 cm)
The Museum of Modern Art, New York. Larry Aldrich Foundation Fund

5. CARS IN POPULAR CULTURE AND POP ART

In 1965 MoMA's founding director, Alfred H. Barr, Jr., introduced *Around the Automobile,* an exhibition of works from the collection, with the observation that "the automobile is once more important to artists yet none celebrates its power, and its specious beauty is left to the advertisers."[1] Instead, the works on view ranged from a print depicting an ominous car-wreck scene and a painting of an auto graveyard "haunted by human derelicts" to a photo-realist painting of a parking meter, wryly titled *Time Expired* (opposite). As objects of consumer desire deeply embedded in postwar popular culture, cars were ripe terrain for artists wishing to relate their practice to the breadth of contemporary experience. Demonstrating a greater awareness of diversity in race, class, and gender, these artists sought to crack apart the monolithic views of modernism and instead offer more nuanced views of society's relationship to technology and consumerism. The breezy optimism and picture-perfect narrative of endless social and technological progress being pedaled by the automotive industry was falling out of sync, it seemed, with the way things actually were. Artists took different approaches to laying bare this discrepancy. Some took inspiration from cars' materiality and construction to

produce new kinds of viscerally compelling sculpture, while others endeavored to objectively document people, their cars, and car-related environments as they found them. Still others, including many Pop artists in Britain and the United States, explored ways of tapping into the accumulated power of automobiles as signifiers of gender, status, and identity.

Cars are an assemblage of parts, one of the most quintessential being the chromed bumper, which 1950s automakers saw as a valuable source of style and distinction. In some cars the bumper was combined with a radiator grille—the notorious "dollar grin" reviled by MoMA's Arthur Drexler as an example of pernicious styling.[2] The American-Haitian artist Jason Seley recognized the sculptural possibilities of these components, which he began working with in the late 1950s after finding inspiration in his wife's purchase, for a dollar, of a 1949 Buick Dynaflow rear bumper. Bumpers and a grille—twisted and welded together so as to deprive these parts of their protective function—form the armature of his chrome-plated *Masculine Presence* (1961; fig. 1). Seley went on to show how human figures, copies of ancient statues, articles of furniture, and even an entire automobile could be made out of this vein of material—in itself a marker of the time and place in which he lived. "To me an automobile bumper is an offering of nature's abundance," Seley said in 1968. "I am as much concerned with its prehistory as the wood-carver with the growing tree."[3] Part of that prehistory was symbolic, as suggested by the title *Masculine Presence*, which satirized the machismo culture surrounding automobiles.

Two other sculptures that cannibalized abandoned car carcasses—the French artist César's *The Yellow Buick* (1961) and John Chamberlain's *Essex* (1960; fig. 2)—appeared alongside *Masculine Presence* in *Around the Automobile*. César had been commissioned by the Buick's owners to transform their old family automobile, which he crushed using a gigantic hydraulic press. The result was a towering monument, permeated with creases and crevices, that retained the car's fetishistic power in a transcendent, immobilized form. Chamberlain constructed *Essex* out of ripped and squashed metal scraps from a variety of Detroit

1.
Jason Seley (American, 1919–1983)
Masculine Presence. 1961
Welded chromium-plated steel automobile bumpers and grille, 7 ft. 2 ⅞ in. × 48 in. × 17 in. (220.6 × 121.9 × 43.2 cm) including base
The Museum of Modern Art, New York. Gift of Dr. and Mrs. Leonard Kornblee

2.
John Chamberlain (American, 1927–2011)
Essex. 1960
Automobile parts and other metal, 9 ft. × 6 ft. 8 in. × 43 in. (274.3 × 203.2 × 109.2 cm)
The Museum of Modern Art, New York. Gift of Mr. and Mrs. Robert C. Scull and purchase

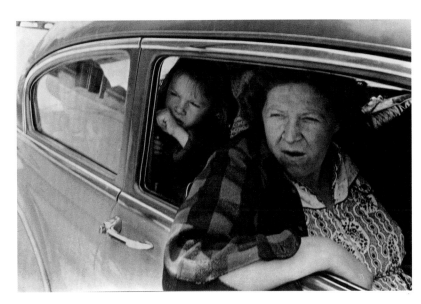

cars, intuitively working with a lush and garish palette of automotive hues—red, blue, yellow, green, black, and orange. Automakers added a lot of white to their colors to achieve a metal-covering opacity that fascinated Chamberlain. Overall, his approach to battered and rusting car wrecks was less reverential than either César's or Seley's: "I think of my art materials not as junk but as garbage. Manure, actually: it goes from being the waste material of one being to the life-source of another."[4]

In 1956, newly arrived in the US from Switzerland, the photographer Robert Frank was eager to look beneath the surface of life in his adoptive country. Purchasing a 1950 Ford Business Coupe with part of a Guggenheim grant (fig. 3), he chose to follow the flow of culture along the nation's highways. For the first time, Frank was exposed to the deep racial fault lines in American society, an experience that profoundly influenced him. In an age of segregation and lynching, annually published "Green Book" directories provided Black drivers with vital listings of gas stations, hotels, and other amenities where they would be welcome. In the introduction to the 1949 edition, the *Green Book*'s author, Victor Hugo Green, looked forward to a day when the guide would no longer be needed: "That is when we as a race will have equal opportunities and privileges in the United States. It will be a great day for us to suspend this publication for then we can go wherever we please, and without embarrassment." Unfettered by such restrictions, Frank crisscrossed the country in his old Ford coupé, chronicling his road trip with more than twenty-seven hundred pictures valorizing a new kind of aesthetic—that of the "snapshot." Eighty-three of these photographs were published in 1959 as *The Americans*, a portfolio that recalibrated notions of American identity by unmasking the idiosyncrasies and racial diversity of this car-borne nation's makeup (fig. 4). Jack Kerouac, whose cult novel *On the Road* had appeared just two years earlier, wrote in the introduction of "the humor, the sadness, the EVERYTHING-ness, the American-ness of these pictures . . . scenes that have never been seen before on film."[5]

Drawing inspiration from Frank's dispassionate documentation of ordinary people and their cars, a new generation of artists took American roadside culture

as their point of departure. Among them was Ed Ruscha, who described how "seeing *The Americans* in a college bookshop was a stunning, ground-trembling experience for me. . . . But I realized this man's achievement could not be mined or imitated in any way. . . . I had to make my own kind of art. But wow! *The Americans*!"[6] His first artist's book, *Twentysix Gasoline Stations* (1963), recorded the banal and repetitive geometry of this vernacular type-form, as viewed from his Ford sedan as he drove along Route 66 between Los Angeles and his native Oklahoma City. Ruscha produced variations on one of the photographs, that of a Standard Oil filling station in Texas, in paint and print, adopting a deadpan Pop aesthetic of clean-cut shapes and bright colors. In one such work, *Standard Station* (1966; fig. 5), the edge of the building's canopy, dramatically foreshortened, is set against a lurid, smoggy sky. Devoid of people, the filling station assumes an eerily still, monumental air. More than just a trademark seen from passing cars, the word "standard" triggers reflection upon the larger brand of America, a nation leveled out and connected by the interstate highway system.

Andy Warhol's career, like Ruscha's, straddled the spheres of commercial and high art. In the 1960s he turned his unemotional gaze to the theme of car accidents, among other macabre subjects, in his Death and Disaster series, silk-screening and multiplying images he culled from newspapers (fig. 6). Commenting on the anaesthetizing effects of mass-produced imagery, the artist observed, "When you see a gruesome picture over and over, it really doesn't have an effect."[7] To the general public—naturally skilled interpreters of mass media—Warhol did not have to explain the tension between images of accident fatalities, widely disseminated by the press, and advertisements showing blandly happy families driving around.

Judy Chicago's first husband was killed in a car accident in Los Angeles in the early 1960s, complicating her already ambivalent relationship to car culture. After graduating from the MFA program of the University of California in Los Angeles, she enrolled at an auto body school in order to learn how to spray-paint—"partly to prove something to the male artists" she'd met in LA, who had

5.
Edward Ruscha (American, born 1937)
Standard Station. 1966
Screenprint, comp.: 19 5/8 × 36 15/16 in. (49.6 × 93.8 cm); sheet: 25 5/8 × 39 15/16 in. (65.1 × 101.5 cm)
Publisher: Audrey Sabol, Villanova, Pennsylvania
Printer: Art Krebs Screen Studio, Los Angeles
Edition: 50
The Museum of Modern Art, New York.
John B. Turner Fund

6.
Andy Warhol (American, 1928–1987)
Orange Car Crash Fourteen Times. 1963
Silkscreen ink on synthetic polymer paint on
two canvases, overall 8 ft. 9 ⅞ in. × 13 ft. 8 ⅛ in.
(268.9 × 416.9 cm)
The Museum of Modern Art, New York. Gift of
Philip Johnson

"repeatedly stated that women couldn't be artists."[8] The only woman in a class of 250 men, Chicago used her newfound skill to customize a series of car hoods in 1964 with biomorphic, female-centric imagery in a multicolored palette (fig. 7). On multiple counts these car hoods were anathema to a male-dominated art establishment—not only due to their yonic forms and decorative style, but as the work of a woman artist repurposing an object considered inherently masculine. Chicago's modified hoods would likely have been met with disapproval by Arthur Drexler, who in 1951 described the bodywork of a car as "a metal skin on which applied decoration, like tattoo marks on the human body, would be of limited esthetic value."[9] Decoration of any kind had long been systematically marginalized, even reviled, within the framework of high modernist aesthetic values enshrined by MoMA. Drexler's mention of tattoos echoed a moralizing comment in a classic and widely read modernist text titled "Ornament and Crime" (1908) by the Viennese architect and theorist Adolf Loos, who notoriously described the modern man who tattoos himself as "a criminal or a degenerate."[10]

Another Los Angeles–based artist to satirize the macho environment around cars and car customization was Kenneth Anger, who gave the topic a homoerotic twist in his 1965 experimental film *Kustom Kar Kommandos* (fig. 8). Panning shots linger lasciviously over a young man as he buffs a customized hot rod in front of a candy pink background to a cover of Bobby Darin's 1959 hit song "Dream Lover." The synergy between car culture and rock 'n' roll reached its apogee in 1960s California. The themes of cars and driving in pop songs invariably emphasized a connection with pure pleasure, excitement, and sex rather than transportation. Hot-rod culture was celebrated by groups like the Beach Boys, Ronny and the Daytonas, the Super Stocks, the Road Runners, and Mr. Gasser and the Weirdos.

Although mass consumer culture developed most fully in the US in the 1950s, it was a British collective of artists, photographers, and architects known as the Independent Group who pioneered a form of Pop art in this decade that appropriated American pulp, much of it car-related. Britain was still culturally

hidebound and in the grip of postwar austerity. To the artists of the Independent Group, the influx of American automobile advertising and printed matter appeared impossibly glamorous, opening up a new iconography of the contemporary world. Over the next fifteen or so years, the two Independent Group members Eduardo Paolozzi and Richard Hamilton continued to adapt such imagery, drawing on their personal stocks of magazines and science journals from the US. For his 1970 series Manikins for Destruction, Paolozzi rephotographed images dealing with traffic-accident simulations and transferred them to etching plates (fig. 9). A year later Hamilton repurposed technical drawings of tire-tread designs for a folio of prints titled *Five Tyres remoulded* (fig. 10). In the meantime, British culture had evolved dramatically, with design, taste, and social patterns becoming more youth-oriented. It is no accident that two iconic British cars identified with 1960s pop culture, the Austin Mini and Jaguar E-Type (see pages 90–93), addressed this emerging market.

7.
Judy Chicago (American, born 1939)
Flight Hood. 1965/2011
Sprayed automotive lacquer on Chevrolet Corvair hood, 42 ⅞ × 42 ⅞ × 4 ⁵⁄₁₆ in. (109 × 109 × 10.9 cm)
Courtesy the artist, Salon 94, New York, and Jeffrey Deitch, New York

8.
Kenneth Anger (American, born 1927)
Kustom Kar Kommandos. 1965
Produced by Puck Film Productions
The Museum of Modern Art, New York

1 Alfred H. Barr, Jr., quoted in The Museum of Modern Art, New York, press release no. 133, December 11, 1965.
2 Arthur Drexler, *8 Automobiles*, exh. cat. (New York: The Museum of Modern Art, 1951), [6].
3 Peter L. Auer, Zevi Blum, H. Peter Kahn, and Milton R. Konvitz, "Jason Seley," Cornell University Faculty Memorial Statement, 1983.
4 John Chamberlain, in "The Poets' Encyclopedia," ed. Michael Andre and Erika Rothenberg, special issue, *Unmuzzled Ox* 4, no. 4 (1979): 178.
5 Jack Kerouac, introduction to *The Americans*, by Robert Frank (New York: Grove Press, 1959), 5.
6 Ed Ruscha, "Six reflections on the photography of Robert Frank," *Tate Etc.*, Autumn 2004.
7 Andy Warhol, "What Is Pop Art?," interview by Gene R. Swenson, *ARTNews* 62 (November 1963): 26.
8 Judy Chicago, *Through the Flower: My Struggle as A Woman Artist* (New York: Doubleday, 1975), 36, 35.
9 Drexler, *8 Automobiles*, [4].
10 Adolf Loos, "Ornament and Crime," in *Programs and Manifestoes on 20th-Century Architecture*, ed. Ulrich Conrads (Cambridge, MA: MIT Press, 1971), 19.

9.
Eduardo Paolozzi (British, 1924–2005)
Untitled (M.I.R.A. Pair), from *The Conditional Probability Machine* (detail). 1970
One from an illustrated book with twenty-five photogravures, plate: 12 ¾ × 7 ⅞ in. (32.4 × 20 cm); page: 22 ¹³⁄₁₆ × 15 ⁵⁄₁₆ in. (58 × 39.5 cm)
Publisher: Editions Alecto, London
Printer: Alecto Studios, London
Edition: 24
The Museum of Modern Art, New York.
Donald H. Karshan Fund

10.
Richard Hamilton (British, 1922–2011)
Untitled, from *Five Tyres remoulded*. 1971
Screenprint from a portfolio of seven screen-prints, one rubber relief, and one collotype, sheet: 23 ⅝ × 33 ⁷⁄₁₆ in. (60 × 85 cm)
Publishers: Professional Prints A.G., Zug, Switzerland, and Eye Editions, Cincinnati
Printer: various printers
Edition: 150
The Museum of Modern Art, New York.
Abby Aldrich Rockefeller Fund for Prints

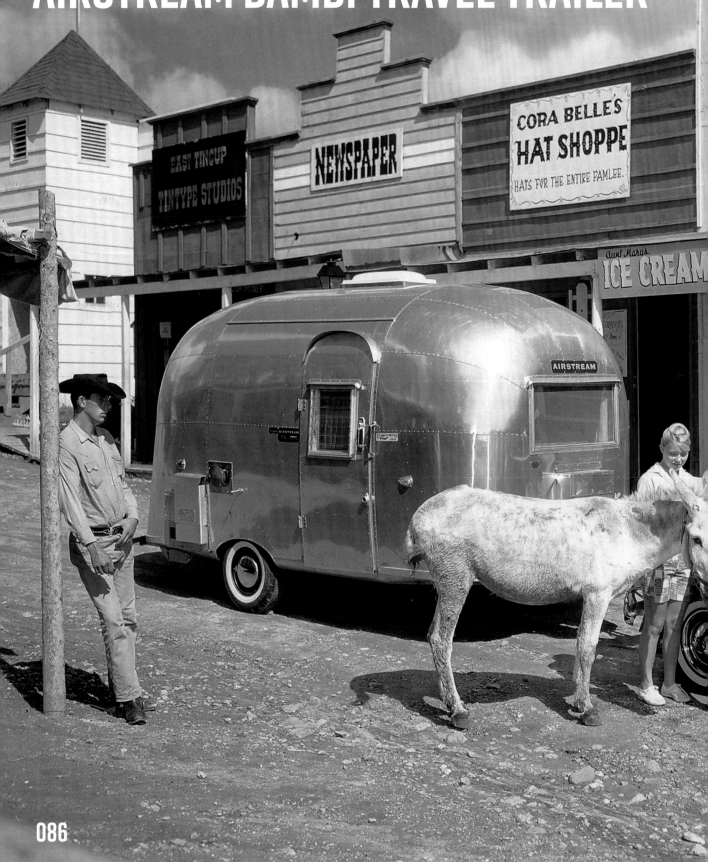

The gleaming Airstream Bambi Travel Trailer epitomizes the American vision of life on the open road. Conceived in the 1920s as a sheltered alternative to tent-camping, Airstream trailers had found widespread appeal among a burgeoning middle class seeking new modes of leisure by the 1950s. The characteristic rounded aluminum body evokes the aerodynamic principles on which the earliest travel trailers were built and is a design feature that has carried through to Airstream's contemporary lineup. A symbol of freedom, progress, and the enduring possibilities of the great outdoors, Airstream trailers remain beloved pillars of American life, so much so that an estimated 70 percent of those produced since the early 1930s remain in use today.

In 1931 Wally Byam constructed the first Airstream prototype from plywood and Masonite, outfitting it with a stove and ice chest for camping trips with his wife, Marion. The design proved so popular among local open-air enthusiasts that he had to quickly move production from his backyard to a factory in Culver City, California. By 1935 Airstream counted no fewer than four hundred competitors; among them was Bowlus-Teller Trailers, a company (founded by a former aeronautical engineer) that produced trailers clad in the same aluminum used for airplane fuselages. Drawn to the shimmering possibilities of this space-age material, Byam purchased Bowlus-Teller at a bankruptcy auction and, in 1936, his company came out with the first all-aluminum trailer, the Airstream Clipper.

Thanks to the Clipper's ingenious design and Byam's marketing prowess, by the end of World War II Airstream was the only travel trailer company that remained in existence. Seeking to capitalize on the optimism and prosperity of the postwar era, Byam embarked on a series of promotional caravan journeys across dozens of countries, from Nicaragua and Switzerland to Malaysia and China. His most famous journey was a seven-month, fourteen-thousand-mile caravan across Africa in 1959–60, beginning in Cape Town and ending in Cairo. During the portion of his trip in Angola, Byam encountered a regionally revered species of miniature deer known in the Umbundu dialect of the Bantu language as "O'Mbambi." The concept for a small and lightweight Airstream trailer called the Bambi was born.

"Never before has Airstream offered you so many reasons to want to make your travel dreams come true," declared a 1963 brochure. The Bambi was among the offerings, providing "more comfort, more convenience, more down-right beauty than ever before." Launched in 1961, the Bambi was true to its name at a diminutive sixteen feet in length—nearly the same size as the average passenger vehicle. But what the single-axle trailer lacked in size it more than made up for in style. Like the Clipper, the structural integrity of the bullet-shaped Bambi came from a seamless single-shell, monocoque skin. The lightweight properties of the all-aluminum exterior lessened the need for heavy bracing or support, allowing the interior to be packed with features. These included a refrigerator and water heater, powered by two five-gallon gas tanks, and a portable compressor for easy tire inflating. At a lean $2,990 (roughly $32,000 in today's dollars), it's no wonder that the Bambi became one of the brand's most successful trailers.

—AG

An Airstream Bambi in the former mining town of Tin Cup, Colorado, 1961

AIRSTREAM BAMBI TRAVEL TRAILER

Designed 1960 (this example 1963)
Manufacturer: **AIRSTREAM, INC.** (Jackson Center, Ohio, est. 1931)

Aluminum body with steel, glass, wood, and other materials
The Museum of Modern Art, New York. Gift of Airstream, Inc.

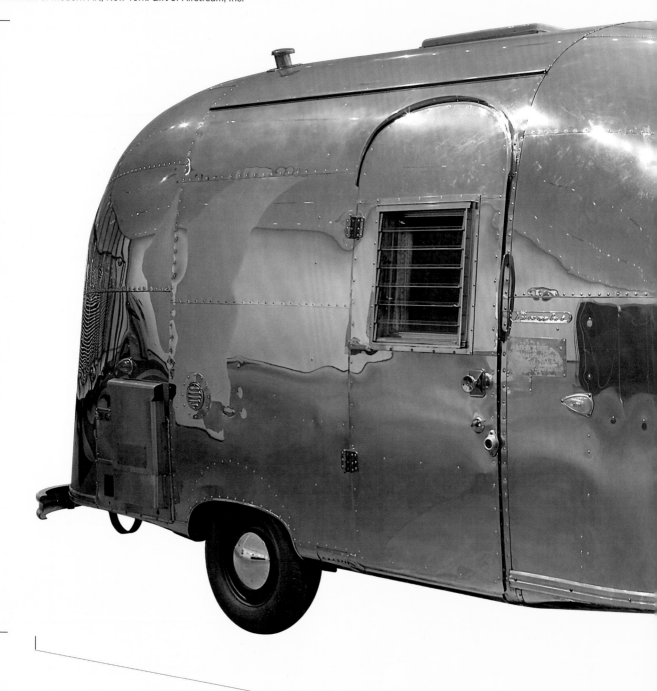

Height: 8 ft. 2 in. (248.9 cm)

Length:
16 ft. 8 in. (508 cm)

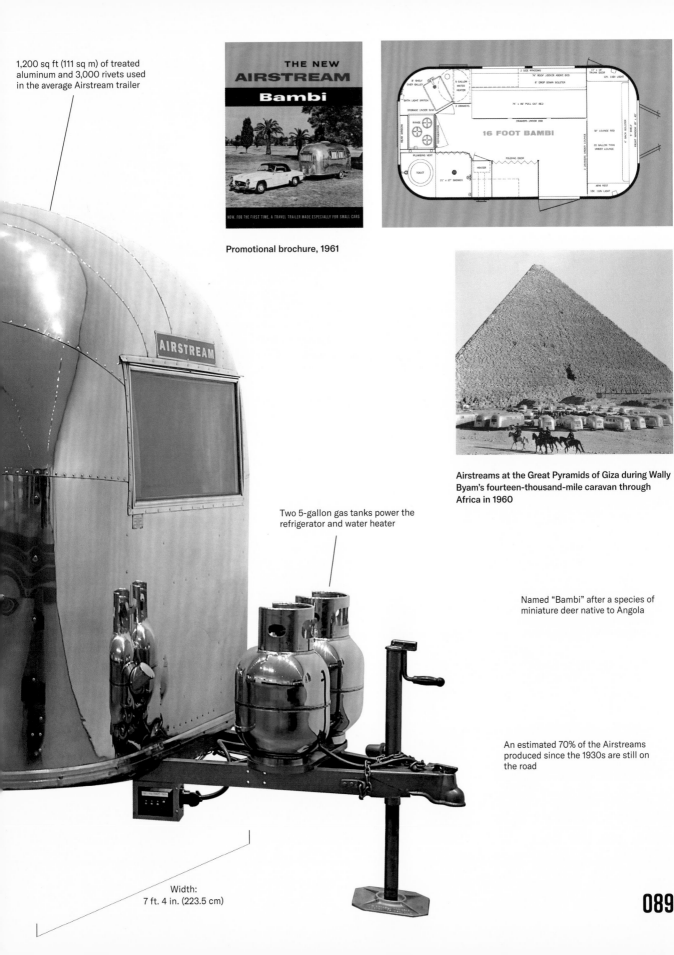

1,200 sq ft (111 sq m) of treated aluminum and 3,000 rivets used in the average Airstream trailer

THE NEW AIRSTREAM Bambi

NOW, FOR THE FIRST TIME, A TRAVEL TRAILER MADE ESPECIALLY FOR SMALL CARS

Promotional brochure, 1961

16 FOOT BAMBI

Airstreams at the Great Pyramids of Giza during Wally Byam's fourteen-thousand-mile caravan through Africa in 1960

Two 5-gallon gas tanks power the refrigerator and water heater

Named "Bambi" after a species of miniature deer native to Angola

An estimated 70% of the Airstreams produced since the 1930s are still on the road

Width:
7 ft. 4 in. (223.5 cm)

JAGUAR E-TYPE ROADSTER

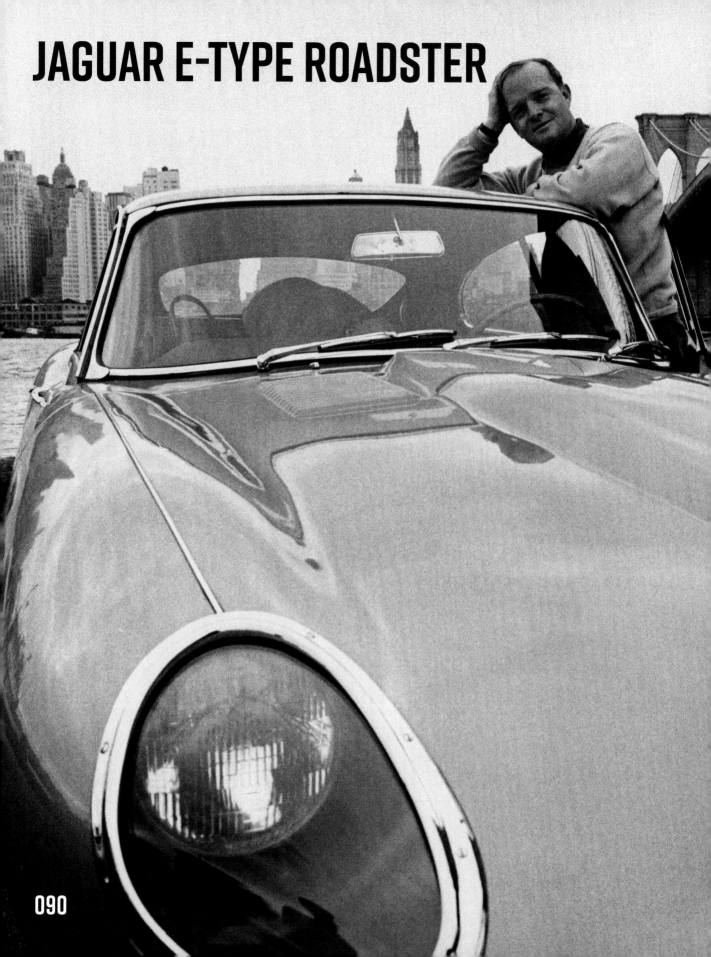

"I want that car, and I want it now," the singer Frank Sinatra allegedly said upon first seeing the Jaguar E-Type (better known in the United States as the XK-E) at the New York Auto Show in 1961. An icon of the swinging sixties, the E-Type matched the design language of a cutting-edge racing car with the amenities of a passenger vehicle. The swooping teardrop shape of this classic roadster may be standard among contemporary sports cars, but at the time of the E-Type's introduction its form was absolutely radical. Its gleaming curves and low-set profile seemed more suited to the racetrack than to city streets. And it was *fast*—a result of the careful aerodynamic analysis that dictated the car's overall design.

Jaguar's origins can be traced to 1922, when Sir Williams Lyons and William Walmsley founded Swallow Side Car, a motorcycle sidecar company, in Coventry, England. By the time Lyons took over the business in 1935, it had evolved to manufacture passenger vehicles and was renamed S.S. Jaguar Cars (the "S.S." was dropped after World War II to avoid associations with Nazism). Automobile racing, which helped propel the mass-cultural obsession with cars at the turn of the century, was at the heart of Lyons's strategy for building a successful British car company. The E-Type's predecessors the Jaguar C-Type and D-Type were developed precisely for this purpose, each winning the 24 Hours of Le Mans—the oldest endurance racing car event in the world—several times throughout the 1950s.

Malcolm Sayer joined Jaguar in 1950 after working as an engineer at the Bristol Aeroplane Company. His experience with airplane technology served him well at an automaker intent on building cars for speed. Unlike traditional passenger car designers, who prioritized features and comforts for the would-be consumer, Sayer focused on the car's silhouette, performing countless wind tunnel tests to hone an exterior that stood up to air resistance from all directions. Every detail—from the tapered body panels and the inset wheel wells to the glass-covered headlamps and the finely shaped front and rear bumpers—was tirelessly calculated to maximize aerodynamic efficiency. Many American car companies of the period, by contrast, only emphasized the aerodynamics of a car's body from hood to tail, as evinced by the rage for tail fins and streamlining.

When the E-Type premiered at the 1961 Geneva Motor Show, it was the fastest large-production passenger car in the world. It could reach sixty-two miles per hour in just over fifteen seconds, a zippy speed for a car built for day-to-day use. And, compared to similar cars from competitors like Ferrari and Aston Martin, it was affordable—making it an instant hit with consumers on both sides of the Atlantic. Owned by celebrities including Brigitte Bardot, Truman Capote, George Harrison, Steve McQueen, and Peter Sellers, the car soon became famous in its own right, starring in countless films and television shows. Today the E-Type has come to symbolize the sexually liberated and free-spirited attitudes of the US and Europe in the 1960s.

—AG

Truman Capote and his Jaguar, with the Brooklyn Bridge and Manhattan skyline in the background. *Vogue* magazine, 1963

JAGUAR E-TYPE ROADSTER

Designed 1961 (this example 1963)
Designers: **SIR WILLIAM LYONS** (British, 1901–1985), **MALCOLM SAYER**
(British, 1916–1970), and **WILLIAM M. HEYNES** (British, 1903–1989)
Manufacturer: **JAGUAR, LTD.** (Coventry, UK)

Steel unibody with fabric top, glass, rubber, and other materials
The Museum of Modern Art, New York. Gift of Jaguar Cars

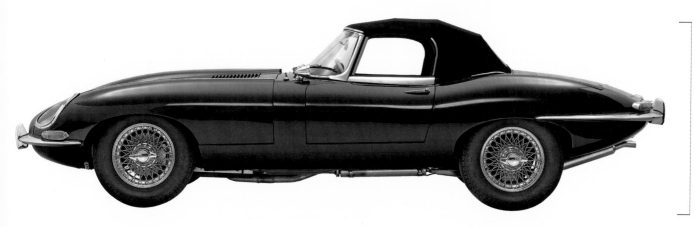

Height: 48 in. (121.9 cm)

Length: 14 ft. 7 in. (444.5 cm)

Graham Hill in a Jaguar E-Type at Oulton Park race
circuit, Little Budworth, UK, 1961

4-speed manual transmission

6-cylinder, 265 hp engine capable
of reaching 150 mph (241 kmh)

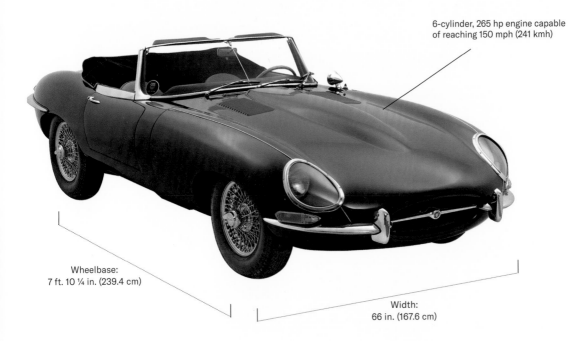

Wheelbase:
7 ft. 10 ¼ in. (239.4 cm)

Width:
66 in. (167.6 cm)

Teardrop-shaped body maximizes
aerodynamic efficiency

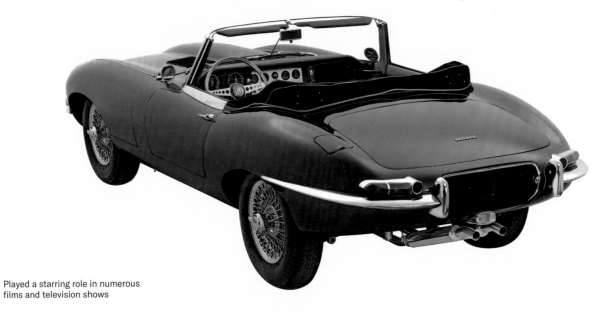

Played a starring role in numerous
films and television shows

Herbert Leupin (Swiss, 1916–1999)
. . . *trink lieber Eptinger!* (Instead drink Eptinger!).
Poster for the mineral water company Eptinger. 1948
Lithograph, 50 ¼ × 35 ¼ in. (127.6 × 89.5 cm).
Printer: Wolfsberg-Druck, Zurich
The Museum of Modern Art, New York. Gift of the Swiss Government

6. CARMAGEDDON

By the 1960s the technological optimism embraced whole-heartedly in the previous decade was starting to wane. While the automobile industry had been an engine of post-war economic growth and improved standards of living, its positive impact was becoming overshadowed by the seemingly intractable problems that came with a car-centric world: traffic-clogged, smoggy cities; suburban sprawl; landscapes scarred by rapacious oil extraction or submerged beneath a spaghetti of roads; and endlessly escalating fatalities, partly attributable to drunk driving. (This last trend was alluded to in a 1948 Swiss advertise-ment for mineral water illustrated by a crumpled road sign [opposite].) "The automobile harms the city and hurts man," stated the Greek urban planner C. A. Doxiadis in an address to the Detroit Economic Club in 1967. "Our life is in danger in the streets. The Automobile makes a dis-agreeable noise and it contaminates the air. People, there-fore, do not simply hide inside buildings, they also close their windows and draw their curtains. . . . Man is turning into a troglodyte. . . . Under the impact of the Automobile and the forces it brings into the City, the center is breaking down, yet we continue to overload it."[1] These issues were extrapolated to an apocalyptic conclusion in the 1963 ani-mated film *Automania 2000* by the British studio Halas

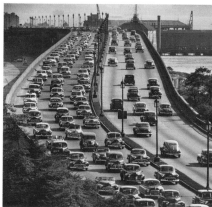

and Batchelor. In the final scenes of this Oscar-nominated satire on technological overkill and automated gridlock, monuments of world civilization—among them the Empire State Building in New York and Big Ben in London—are submerged beneath a tidal wave of immobilized cars (fig. 1). All human life is extinguished in the maws of cars that begin to self-reproduce—the ultimate in automation. The film's critique of auto-driven consumerism echoed that of Vance Packard's best-selling book *The Waste Makers* (1960) and Ralph Nader's *Unsafe at Any Speed* (1965). Conceding that the lives of most Americans had become deeply intermeshed with car culture and consumer spending, both authors advocated improvements to cars' fuel efficiency and safety standards rather than eliminating cars entirely. This challenge—mitigating the harm wrought by cars while still accommodating them—is one with which planners, architects, environmentalists, manufacturers, consumers, and politicians have continued to struggle to this day.

In the decades following World War II, a huge number of car-oriented master plans were generated for urban projects in the developing world, often involving an international network of collaborators. Doxiadis participated in many of them, most famously Islamabad, the city built in 1960 to replace Karachi as the capital of Pakistan. Drawing on studies he'd conducted earlier in his career on human settlements dating back to Ancient Greece, Doxiadis attempted to address the needs of city dwellers while respecting the topography of the natural landscape, separating high- and low-speed traffic with a square formation of four highways that define the extent of the region. In the United States architects and planners had trouble coming up with solutions for untangling traffic congestion and reducing the haphazard proliferation of parking lots, issues that plagued postwar cities (fig. 2). Gridlock was particularly burdensome in New York, where the construction of a Lower Manhattan Expressway that would link New Jersey to Brooklyn, Queens, and Long Island via the Holland Tunnel and the Manhattan and Williamsburg bridges was hotly debated for years. The Ford Foundation commissioned a speculative study of the proposed expressway from Paul Rudolph in 1967 (fig. 3). Designed to leave New York's

1.
John Halas (British, born Hungary. 1912–1995)
Joy Batchelor (British, 1914–1991)
Automania 2000. 1963
Produced by Halas and Batchelor Cartoon Films
The Museum of Modern Art, New York

2.
Andreas Feininger (American, born France. 1906–1999)
West Side Highway. c. 1945
Gelatin silver print, 15 1/16 × 18 1/2 in. (38.3 × 47 cm)
The Museum of Modern Art, New York. Gift of the artist

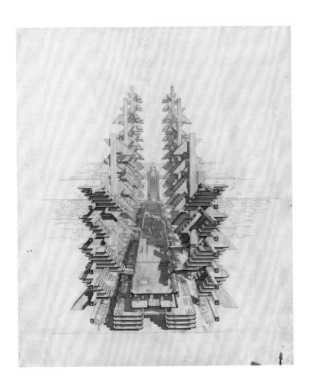

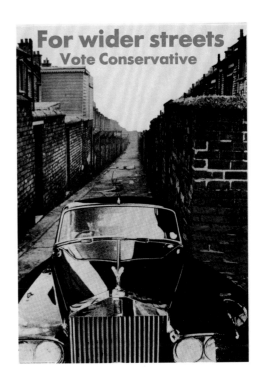

preexisting infrastructure intact, Rudolph's (unrealized) plan suggested a new approach to city building, in which transportation networks could bind instead of divide communities. He envisioned a Y-shaped corridor that would connect with the existing bridge and rail systems. At the gateways to Manhattan, this corridor would be flanked by tall, stepped-back residential buildings and multilevel stacks of pedestrian plazas, people movers, and parking. It was a mind-bogglingly audacious scheme that reinforced the primacy of the car. "There is a double scale now that has never existed before," wrote Rudolph, "a scale for pedestrians and a scale for automobiles, and we have to learn how to make a transition from one to the other."[2]

Although Rudolph brought the project to life on paper, the expressway had originally been conceived by the influential (and controversial) planner Robert Moses, who implemented myriad brutally surgical schemes over the four decades he was head of the New York and Long Island state park commissions. The highways and road bridges built during his tenure cut through swaths of poor, largely Black and Latino residential districts of the city's five boroughs, physically segregating communities along racial lines. The same pattern, referred to as "white roads through black bedrooms" by a *New York Times* reporter in 1967, was being replicated in many cities across the US.[3] What followed was a disproportionate loss of access to public transportation, parks, and clean air among already disadvantaged sectors of the populace who lacked political clout.

Battles over street space had dogged the car since its first appearance as a toy of the wealthy terrorizing all pedestrians and wildlife in its path. The class conflict behind road planning was the target of a poster satirizing the British 1974 elections created by Klaus Staeck, a German political and environmental activist (fig. 4). The slogan "For wider streets, Vote Conservative" is illustrated by a fat Rolls Royce hogging the lane in an area of cramped housing with few car-owning inhabitants, judging by the absence of garages and parked cars. The poster made it abundantly clear whose interests would be best served by imposing wide streets in such areas: those of the affluent and their polluting cars. The

3.
Paul Rudolph (American, 1918–1997)
Lower Manhattan Expressway Project, New York.
Perspective to the east. 1972
Ink and graphite on paper, 40 × 33 ½ in.
(101.6 × 85.1 cm)
The Museum of Modern Art, New York. Gift of
The Howard Gilman Foundation

4.
Klaus Staeck (German, born 1938)
For Wider Streets Vote Conservative. Satirical
poster for British elections. 1974
Lithograph, 33 ⅛ × 23 ⅜ in. (84.1 × 59.4 cm)
Printer: Gerhard Steidl, Göttingen, Germany
The Museum of Modern Art, New York. Gift of
the designer

Conservative government did indeed pursue aggressive pro-roads policies—often at the expense of working-class people, whose communities were chopped up or erased—until slowed in the 1980s by mounting opposition from anti-road protestors and environmentalists.

To cope with rocketing levels of traffic, many postwar governments developed high-speed national road networks. The US Federal Aid Highway Act of 1956 allocated twenty-five billion dollars to the construction of an interstate highway system. In 1964 the Transportation Research Board commissioned academics at the Massachusetts Institute of Technology to conduct a study on "the esthetics of urban highways." As its title, *The View from the Road*, suggested, the study was more focused on the standpoint of drivers and their passengers than of those living beside major roads. The compelling cover designed by Muriel Cooper complemented the study's aim to deal with highways as potential works of art and as sources of driving pleasure rather than frustration and road rage (fig. 5). Effective signage was key in efforts to improve driver experience and safety, reestablishing coherence and order along the road. The system created in Britain by the graphic designers Jock Kinneir and Margaret Calvert, first for the new M1 motorway connecting London and Leeds in the late 1950s, then for the entire country in the early 1960s, set a standard that was widely emulated (fig. 6). They began by creating a new typeface called Transport, which used both upper- and lowercase letters (up until then British road signs had been all-capitals) and could be easily understood at speed. Variable in weight, the typeface was paired with pictograms and set against different background colors to maximize the clarity of communication.

One of the greatest shortcomings of the postwar motorcar was the sheer amount of gasoline and oil it burned. Although climate change (and the role combustion engines play in accelerating it) wouldn't become a major topic of public concern until the 1980s, the more immediate ravages wrought by oil extraction were clearly visible in oil-rich countries like Venezuela. Massive reserves of the fossil fuel were first discovered in the basin of Lake Maracaibo, an inlet of the

5.
Muriel Cooper (American, 1925–1994)
Cover of the book *The View from the Road*, by Donald Appleyard, Kevin Lynch, and John R. Myer. 1965
Published by MIT Press, Cambridge, Massachusetts
The Museum of Modern Art Library, New York

6.
Jock Kinneir (British, 1917–1994)
Margaret Calvert (British, born 1936)
Primary-route road sign. Originally designed 1957–67 (this version, designed with assistance from Simon Morgan, 2021)
Designed for the Ministry of Transport (now Department for Transport), UK
Manufacturer: Royal British Legion Industries (Aylesford, UK, est. 1919)
Retroreflective sign face sheeting, composite substrate, aluminum alloy support channels, 60 1/16 × 70 × 1 5/16 in. (152.5 × 177.8 × 3.3 cm)
The Museum of Modern Art, New York.
Committee on Architecture and Design Funds

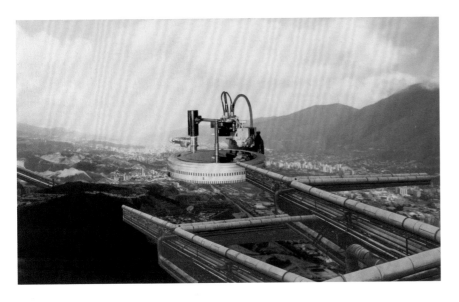

Caribbean Sea, in the 1920s, and by 1945 the country was producing about one million barrels of oil per day. It reached an all-time high of 3.8 million barrels per day in 1970, making it one of the world's largest exporters of oil. Jorge Rigamonti was among a new generation of Venezuelan architects involved in developing an infrastructure for the petroleum industry. At the same time that he actively took part in the country's heroic engineering projects, Rigamonti considered the environmental impact of these initiatives in a powerful series titled Collages About the City (Collages sobre la Ciudad, 1970; fig. 7). Combining photographs and found images from magazines with drawings of imaginary architectural interventions, he communicated a vision that was simultaneously utopian and dystopian.

Growing critical attention to the ecological and social effects of modern lifestyles was evidenced by the emergence of countercultural magazines like the *Whole Earth Catalog*. Published in the US several times a year from 1968 to 1972, and intermittently thereafter until 1998, the *WEC* advocated conserving the environment and self-sustaining, simple living. Promoting alternatives to a relentless cycle of consumption, the magazine offered its readers open-source designs and low-tech know-how. Because the fuel-efficient Volkswagen Beetle (see pages 42–45) was a popular choice for those pursuing a greener lifestyle, one of the books advertised in the *WEC* was a do-it-yourself repair manual "for the Compleat Idiot" on *How to Keep Your Volkswagen Alive*, first published in 1969 (fig. 8). The author of the manual, John Muir—a former aerospace engineer (and distant relative of the famous naturalist of the same name) who ran a garage in Taos, New Mexico—felt it was possible to extend the product life of the Beetle's small horsepower engine through careful management and repair. "You must do this work with love, or you fail,"[4] he advised his readers. "Your car is constantly telling your senses where it's at: what it's doing and what it needs. . . . I don't expect you to become a mechanic—I have done that! My understanding and knowledge will be yours as you work."[5]

The Standard Oil filling station in Amarillo, Texas, that so mesmerized Ed Ruscha (see fig. 5 on page 82) is now long gone, but traveling along that

7.
Jorge Rigamonti (Venezuelan, 1940–2008)
Caracas Transfer Node 2. 1970
Cut-and-pasted lithograph, 9 ¼ × 15 in. (23.5 × 38.1 cm)
The Museum of Modern Art, New York. Latin American and Caribbean Fund

8.
Peter Aschwanden (American, 1942–2005)
Cover of the book *How to Keep Your Volkswagen Alive* by John Muir. 1971
Published by John Muir Publications (Santa Fe, New Mexico)
The Museum of Modern Art, New York. Purchase

stretch of Route 66 one can see a row of ten half-buried Cadillacs with their rear ends in the air, all listing at the same sixty-degree angle. Appearing like some monument to a lost cult—a Stonehenge for the twentieth century—the cars were first installed in 1974 by Ant Farm, a San Francisco–based collective of artists and architects, for the work *Cadillac Ranch* (fig. 9). The line of wrecked, graffiti-smothered Cadillacs traces the development of the tail fin from 1949 to 1963, forming an absurd evolutionary narrative that ends with the cars' collective nosedive. More than any other element of the non-functional and excessive styling critiqued by Vance Packard in *The Waste Makers*, the tail fin had come to stand for a period in US automotive history marked by manic consumerism and near-annual changeover of car models (part of the industry's larger scheme of planned obsolescence). Although *Cadillac Ranch* recalls this bygone era, it was conceived at the time of the first oil crisis in 1973–74, when members of the Organization of Arab Petroleum Exporting Countries imposed an oil embargo against the US and other countries for supporting Israel during an Arab-Israeli conflict known as the Yom Kippur War. The crisis was the first of many to demonstrate just how dependent global economics and day-to-day living had become on the steady flow of oil, a situation on which James Wines and Emilio Sousa—both members of SITE, a New York–based architecture and environmental arts organization—reflected in a public art installation titled *Ghost Parking Lot* (1977; fig. 10). The two artists partially submerged twenty defunct cars beneath a thin skin of asphalt in a parking lot outside a shopping mall in suburban Connecticut. A *New York Times* piece observed that "automobiles consume petroleum and asphalt is a petroleum product . . . used here to consume the automobiles"—a cycle that Wines intended to prompt a questioning of "private mobility . . . as a continuing way of life."[6] Many members of the public had already been doing so unprovoked, as concerns about the health and environmental repercussions of gas-guzzling cars were steadily mounting, stimulating automakers to develop cars with greater fuel efficiency and initiating a wider search for more sustainable energy sources.

9.
Ant Farm (United States, est. 1968)
Chip Lord (American, born 1944)
Hudson Marquez (American, born 1947)
Doug Michels (American, 1943–2003)
Cadillac Ranch. US Route 66, Amarillo, Texas. 1974

1 C. A. Doxiadis, "Man, City, and Automobile," *Ekistics* 25, no. 146 (January 1968): 13–16.

2 Paul Rudolph, *Writings on Architecture* (New Haven, CT: Yale University Press, 2009), 86.

3 B. Drummond Ayres, Jr., "White Roads through Black Bedrooms," *New York Times*, December 31, 1967.

4 John Muir and Tosh Gregg, *How to Keep Your Volkswagen Alive: A Manual of Step-by-Step Procedures for the Compleat Idiot* (Emeryville, CA: Avalon Travel, 2001), 7.

5 Ibid., 3.

6 James Wines, quoted in Carter B. Horsley, "'Ghost Parking Lot' Art Project in Connecticut to Be Dedicated," *New York Times*, May 27, 1978.

10.
SITE (United States, est. 1970)
James Wines (American, born 1932)
Emilio Sousa (American, born 1944)
Ghost Parking Lot. National Shopping Centers, Hamden, Connecticut. 1977
Production by Depersia Corporation, Glastonbury, Connecticut

SMART CAR COUPÉ

The sprite profile of the Smart Car was designed with urban living in mind. Introduced in 1998, the highly fuel-efficient vehicle appealed to city dwellers, especially in Europe, where gas prices are particularly high. Its compact proportions are well-suited to maneuvering narrow streets and negotiating tight parking spots, making it a natural successor to the city cars popular at mid-century, such as the Fiat 500 (see pages 46–49). Since its debut more than two decades ago, the Smart Car has sold in millions around the world, setting the standard for the ecologically minded vehicles that will play a critical role in curbing the impacts of climate change.

Smart is the result of a collaboration between Mercedes-Benz and the Swatch watch company, who together founded the joint enterprise, Micro Compact Car AG, in 1994. They envisioned a city car that would combine superb fuel efficiency with cutting-edge style. The resulting automobile, designed by a team led by Gerhard Steinle, is roughly eight feet long—half the size of the average passenger vehicle, meaning that two Smart Cars can fit into the equivalent of a single parking space. Gas mileage on this two-door model—eventually a cabriolet and a four-door car were also added to the Smart lineup—was estimated to be about forty-eight miles per gallon, a marked improvement over cars with much larger footprints. A reinforced black steel frame—branded the Tridion safety cell—makes the passenger cabin an integral unit, allowing the designers to eliminate the front and back ends of a more traditional automobile. By placing the engine of the car below the seats, Steinle and his team were able to offer ample roominess for both passengers—an unexpected bonus given the car's diminutive size. The exterior shell is clad in thermoplastic panels, a more lightweight and durable material than the metal typically used for car bodies. These panels can be exchanged for a different set should the owner desire a color change.

Today the field of subcompact, environmentally conscious vehicles is more crowded than when the Smart Car first hit the road. New technologies, including hybrid gas-and-electric drivetrains pioneered by Japanese automakers like Toyota, are increasingly common across entire fleets, as are all-electric vehicles. And as the market has evolved, so, too, has Smart. No longer sold in the United States as of 2019, the Smart Car is now fully electric, replacing yesterday's gasoline engine with zero-emissions technology.

—AG

Promotional photograph of the Smart Car, 1998. Advertising materials from its launch described it as "a trendsetter in personal urban mobility" that "feels at home in the narrowest of alleys in large cities."

SMART CAR COUPÉ

Designed 1998 (this example 2002)
Manufacturer: **MICRO COMPACT CAR SMART GMBH**
(Germany and France, est. 1994)

Steel frame, thermoplastic body panels, and other materials
The Museum of Modern Art, New York. Gift of the manufacturer,
a company of the DaimlerChrysler Group

Height: 61 in. (154.9 cm)

Length: 8 ft. 2 ⅜ in. (249.9 cm)

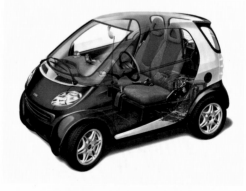

Dent-resistant, lightweight body panels made of recycled plastic

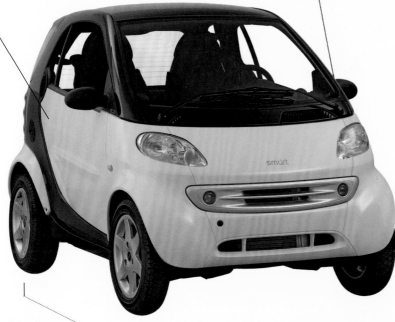

At 8 ft (2.4 m) long, half the size of the average 4-passenger car

Wheelbase:
71 ¾ in. (182.2 cm)

Black steel frame—branded the Tridion safety cell— ensures maximal road safety

Body panels interchangeable to allow for color customization

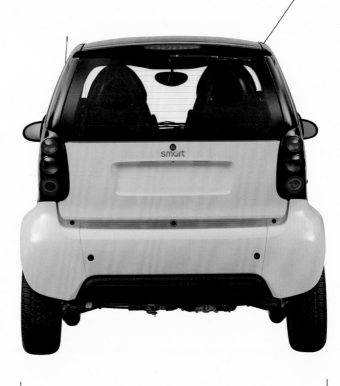

3-cylinder engine mounted under passenger seat to save space

Width: 68 in. (172.7 cm)

ACKNOWLEDGMENTS

Like any machine, a car is only as good as the sum of its parts, and the same holds true for exhibitions and catalogues. Even in the best of times, *Automania* would not have been possible without the support of a huge team to keep its engine humming. In the midst of a global pandemic, with colleagues juggling their lives and livelihoods and the shock of a society transformed, we wish to express a profound debt of gratitude to the many people who helped realize this complex project. Our machine would simply have stopped running were it not for you.

For vital support we wish to thank Glenn D. Lowry, The David Rockefeller Director of The Museum of Modern Art, and the Museum's board of trustees.

Our thanks go to the leaders of the MoMA departments that helped make *Automania* happen, including Ramona Bannayan, former Senior Deputy Director, Exhibitions and Collections; Peter Reed, former Senior Deputy Director, Curatorial Affairs; Sarah Suzuki, Senior Deputy Director, Curatorial Affairs; Lana Hum, Director, Exhibition Design and Production; Kate Lewis, The Agnes Gund Chief Conservator, Conservation; and Rob Jung, Manager, and Tom Krueger, Assistant Manager, Art Handling and Preparation. To Martino Stierli, The Philip Johnson Chief Curator, Department of Architecture and Design, we extend our special thanks for your continued belief in this project.

We owe tremendous thanks to our core exhibition team, including Aimee Keefer, Exhibition Designer, Exhibition Design and Production, whose calm, steady, and enthusiastic voice transformed our wild dreams into a beautiful reality; Chloe Capewell, Assistant Coordinator, Exhibition Planning and Administration, whose nimble organization and keen attention to detail kept us on track and on schedule; and our fabulous registrar team, including Steven Wheeler, Associate Registrar, and Nanci Velez, Senior Registrar Assistant, Collection Management and Exhibition Registration, who managed the object shipping, logistics, and care with good humor and aplomb.

We are hugely indebted to the many members of the Department of Conservation who ensured that every object in the exhibition sparkled: Anny Aviram, Senior Paintings Conservator; LeeAnn Daffner, Photography Conservator; Peter Oleksik, Associate Media Conservator; and Annie Wilker, Associate Paper Conservator. Most especially we wish to thank Roger Griffith, Sculpture and Objects Conservator, whose patience, collaborative spirit, and geniality guided the thorny project of restoring several cars in the collection and putting them on display outdoors.

We also wish to thank Volkswagen AG, Wolfsburg, Germany, for their enthusiastic support of our conservation efforts, which allowed us to restore the Beetle to its original glory. This work would not have been possible without the deft hands of Brian Oliver and Kent Bain from Automotive Restorations, Inc., in Stratford, Connecticut.

The Museum's collecting and research departments helped to make *Automania* a richer, more expansive exhibition. We are grateful to colleagues in our own department, including Arièle Dionne-Krosnick, former Curatorial Assistant; Katya Hall, Department Assistant; Pamela Popeson, former Preparator; and our interns Malaika Shuck, Margaret Simons, and Anna Talley. In other departments we thank Emily Cushman and Kunbi Oni, Collection Specialists, in Drawings and Prints; Anne Morra, former Associate Curator, and Ashley Swinnerton, Collection Specialist, in Film; Athena Christa Holbrook, former Collection Specialist, and Erica Papernik-Shimizu, Associate Curator, in Media and Performance Art; Lily Goldberg, Collection Specialist, in Painting and Sculpture; Sarah Meister, former Curator, Tasha Lutek, Collection Specialist, and Phil Taylor, Curatorial Assistant, in Photography; Jennifer Tobias, former Reader Services Librarian, Jillian Suarez, Head of Library Services, Ana Marie, Archivist, and Elisabeth Thomas, Assistant Archivist, in Archives, Library and Research Collections.

We owe special thanks to the external partners who helped us in our research endeavors and lent to the exhibition, most especially to Nicola and Giorgio Bulgari and the entire team at the NB Center for American Automotive Heritage in Allentown, Pennsylvania, who shed light on the production and res-toration of classic cars and who graciously loaned several 1930s automobile parts to the exhibition. For their expert knowledge and experience we thank Jennifer Gray and Pamela Casey at the Avery Architectural and Fine Arts Library, Columbia University, New York; Margaret Calvert; Ken Gross; Roberto Giolito, Fiat Chrysler Automobiles N.V., Turin; Simon Morgan, Buchanan Computing Ltd., London; Dr. Fred Simeone, Simeone Foundation Automotive Museum, Philadelphia; Thomas Seydoux; Hampton C. Wayt; and James Wines. Finally, a huge thank you to our other lenders and licensors, including Kenneth Anger; Brian Butler of Anger Management, Los Angeles; Judy Chicago; Salon 94, New York; Jeffrey Deitch, New York; Ford Motor Company, Dearborn, Michigan; General Motors Company, Detroit; Vivien Halas of The Halas and Batchelor Collection, Lewes, England; Mercedes-Benz AG, Stuttgart; Jon Shirley; SITE–James Wines LLC, New York; and Warner Bros., Burbank, California.

This book was no small undertaking, but it was skillfully managed by MoMA's fabulous Department of Publications, which championed this project long before the exhibition had taken shape. It was brilliantly edited by Jackie Neudorf, Assistant Editor, with the support of Don McMahon, Editorial Director, and designed with flair and enthusiasm by Amanda Washburn, Senior Designer. We also owe many thanks to Christopher Hudson, former Publisher; Hannah Kim, Business and Marketing Director; and Curtis Scott, Associate Publisher, for helping to make this book a reality, and to Marc Sapir, Production Director,

and Matthew Pimm, Production Manager, for bringing it to life. Special thanks as well to Naomi Falk, Rights Coordinator, for seeing us through the complex image-rights process, and to Emily Hall, Editor, and Sophie Golub, Department Manager, for their additional support.

Our Imaging and Visual Resources colleagues handled the job with grace and calm. Our appreciation goes to Robert Kastler, Director, and his team, including Paul Abbey, Preparator; Cait Carouge, Digital Image Archivist; Robert Gerhardt, Collections Photographer; Kurt Heumiller, Studio Production Manager; Jonathan Muzikar, Senior Collections Photographer; and John Wronn, former Collections Photographer.

We extend wholehearted thanks to the various people who brought the exhibition to its physical manifestation, including Elle Kim, Associate Creative Director, Claire Corey, Production Manager, and Damien Saatdjian, Art Director, Creative Team; Derek Flynn, former Retail Art Director, Retail; Peter Perez, Frame Shop Foreman, and his team of brilliant framers; Bryan Reyna, Paint Shop Foreman, and his dedicated and hard-working team; and Aaron Harrow, AV Design Manager, Mike Gibbons, AV Exhibitions Foreperson, and the rest of the stellar Audio Visual Department.

We also wish to recognize the contributions of other great colleagues across the Museum, including Sara Bodinson, Ava Childers, James Grooms, Meagan Johnson, Meg Montgoris, Olivia Oramas, Jessica Smith, and Anna Luisa Vallifuoco.

I can't begin to convey the gratitude I feel for having had two extraordinary co-curators on my team: Paul Galloway, fearless collection specialist and resident car buff, whose early case of "automania" helped make this exhibition a reality; and Andrew Gardner, whose creative vision and careful attention to detail kept this ambitious project from running off the road. Thank you for making this project a true pleasure to work on.

Finally, from each of us, a continued and sustained thanks to our partners Paul Stirton, Kimi Weart, and Alex Batkin, without whose support none of this would have been possible.

—JULIET KINCHIN

PHOTOGRAPH CREDITS

In reproducing the images contained in this publication, The Museum obtained the permissions of the rights holders whenever possible. In those instances where The Museum could not locate the rights holders, notwithstanding good faith efforts, it requests that any information concerning such rights holders be forwarded so that they may be contacted for future editions.

Courtesy Airstream, Inc.: 89 (top left, top right); photo Ardean R. Miller III: 86–87; photo Pete Turner, 1960: 89 (center right)
© The Josef and Anni Albers Foundation / Artists Rights Society (ARS), New York, 2021: 53 (fig. 4)
© 1965 Kenneth Anger: 84 (fig. 8)
© 2021 Artists Rights Society (ARS), New York: 29 (fig. 3), 31 (fig. 6)
© 2021 Artists Rights Society (ARS), New York / VG Bild-Kunst, Bonn: 53 (fig. 3), 54
© 2021 Artists Rights Society (ARS), New York / ADAGP, Paris: 32 (fig. 8)
© 2021 Artists Rights Society (ARS), New York / SIAE, Rome: 33
Courtesy Autocar: 21 (bottom right)
Sergio Azenha / Alamy Stock Photo: 92 (bottom right)
Bernhard, Lucian, © 2021 Artists Rights Society (ARS), New York / VG Bild-Kunst, Bonn: 4–5, 32 (fig. 7)
© Vern Blosum, courtesy the Vern Blosum Estate: 78
Margaret Bourke-White via Getty Images: 40
© 2021 Estate of Margaret Bourke-White / Licensed by VAGA, New York, NY: 36 (fig. 2)
© 2021 Estate of Paul Cadmus: 57 (figs. 10, 11)
© 2021 Henri Cartier-Bresson/Magnum Photos, courtesy Fondation Henri Cartier-Bresson, Paris: 14 (fig. 7)
© Center for Creative Photography, Arizona Board of Regents: 37 (fig. 4)
© Judy Chicago, courtesy the artist, Salon 94, New York, and Jeffrey Deitch, New York: 84 (fig. 7)
Department of Transport, UK: 12 (fig. 4), 98 (fig. 6)
© 2021 Fairweather & Fairweather LTD / Artists Rights Society (ARS), New York: 80 (fig. 2)
© 2021 Estate of Andreas Feininger: 96 (fig. 2)
Centro Storico Fiat, Turin, Italy: 48 (bottom left, bottom right)
Fiat Chrysler Automobile, photo Alberto Alquati: 46–47
© F.L.C. / ADAGP, Paris / Artists Rights Society (ARS), New York, 2021: 52 (fig. 1), 55 (fig. 6)
© Fondation Foujita / Artists Rights Society (ARS), New York / ADAGP, Paris, 2021: 28 (fig. 1)
© 2021 Robert Frank: 81 (figs. 3, 4)
Courtesy General Motors: 62, 64, 68
Courtesy Good Design LLC: 69
© 2021 Eberhard Grames: 1
Florian Grout – RS Magazine: 74–75
© 1963 Halas and Batchelor: 96 (fig. 1)
© R. Hamilton. All Rights Reserved, DACS and ARS 2021: 85 (fig. 10)
Andrew Harris / Alamy Stock Photo: 92 (bottom center)
© 2021 Heirs of Josephine N. Hopper / Licensed by Artists Rights Society (ARS), New York: 13 (fig. 5)
Courtesy Kidston SA: 58–59, 60 (bottom left, bottom center)
© 2021 The Lane Collection: 34
Bud Lee Picture Maker: 100
Photograph Warren K. Leffler. Library of Congress, Prints & Photographs Division, U.S. News & World Report Magazine Collection: 42–43

© Mercedes-Benz AG: 102–3, 104 (bottom left, bottom center)
Mercedes-Benz Classic: 50
Courtesy Mineralquelle Eptingen AG: 94
© 2021 Mouron AM.Cassandre: 38–39, 72 (fig. 7)
Digital Image © 2021 The Museum of Modern Art, New York: front cover (Cisitalia, Volkswagen), 8–9, 10, 11, 16, 20 (bottom left, bottom right), 36 (fig. 2), 37 (fig. 3), 38 (figs. 5, 6), 38–39 (fig. 7), 39 (fig. 8), 40, 53 (figs. 3, 4), 55 (figs. 6, 7), 56 (fig. 8), 60 (top, bottom right), 61 (top, bottom), 65 (figs. 2, 3), 67 (fig. 5), 72 (top), 88–89, 94, 96 (fig. 1), 97 (figs. 3, 4); photo Peter Butler: 57 (fig. 10); photo Denis Doorly: 99 (fig. 7); photo Robert Gerhardt: 17 (figs. 11, 12), 18–19, 29 (fig. 3), 52 (fig. 1), 53 (fig. 3), 56 (fig. 9), 98 (fig. 5), 99 (fig. 8); photo Thomas Griesel: 14 (figs. 7, 8), 33, 69, 85, (fig. 10), 104 (top); photo Kate Keller: 4–5, 31 (fig. 6), 32 (fig. 7); photo Paige Knight: 78, 83, 105 (top, bottom); photo Paige Knight and Erik Landsberg: 20 (top), 21 (top); photo Jonathan Muzikar: front cover (Fiat, Jaguar), 12 (fig. 3), 13 (figs. 5, 6), 24 (top, bottom left, bottom right), 25 (top, bottom), 44 (all), 45 (top, bottom), 48 (top), 49 (top, bottom), 57 (fig. 11), 67 (fig. 6), 76 (top), 77 (top, bottom), 80 (fig. 1), 92 (top), 93 (top, bottom); photo Michael Nagle: 73 (top, bottom); photo Mali Olatunji: 31 (fig. 5); photo John Wronn: 1, 2, 6–7, 15, 26, 28 (figs. 1, 2), 32 (fig. 8), 34, 36 (fig. 1), 37 (fig. 4), 54, 72 (bottom right), 80 (fig. 2), 81 (figs. 3, 4), 82, 84 (fig. 8), 85 (fig. 9), 96 (fig. 2), back cover
© The Paolozzi Foundation, licensed by DACS and ARS, 2021: 12 (fig. 3), 85 (fig. 9)
© David Petersen: 30
© 2021 Estate of Pablo Picasso / Artists Rights Society (ARS), New York: 13 (fig. 6)
Courtesy Matthew Pimm: 70–71, 72 (bottom left)
Reproduction from the collection of the Polish Institute of Art: 52 (fig. 2)
Photo John Rawlings/Condé Nast via Getty Images: 90–91
© 2021 Arch. Jorge Rigamonti: 99 (fig. 7)
Modern Times © Roy Export S.A.S.: 41
© The Estate of Paul Rudolph, courtesy the Paul Rudolph Foundation: 97 (fig. 3)
© 2021 Edward Ruscha: 82, back cover
Reproduced with the permission of Shell Brands International, courtesy Shell Heritage Art Collection: 16
© Shell-Mex and B.P. Ltd and Simon Rendall. Reproduced courtesy the BP Archive: 39 (fig. 8)
© 2021 Ketaki Sheth: 2
Collection of Jon Shirley, photo Spike Mafford, Zocalo Studios: 66
Courtesy SITE – James Wines LLC: 101 (fig. 10)
Courtesy Sean S. Smith Photography: 76 (bottom left, bottom right)
Courtesy Klaus Staeck: 97 (fig. 4)
Courtesy the Estate of Ralph Steiner: 37 (fig. 3)
Terre Blanche/Photononstop: 22–23
© Gemma De Angelis Testa: 67 (fig. 5)
Trinity Mirror / Mirrorpix / Alamy Stock Photo: 92 (bottom left)
© 1969 by Van Der Zee: 15
© 2021 The Andy Warhol Foundation for the Visual Arts, Inc. / Licensed by Artists Rights Society (ARS), New York: 83
© 2021 Frank Lloyd Wright Foundation. All Rights Reserved. Licensed by Artist Rights Society: 55 (fig. 7), 56 (figs. 8, 9)

MISCELLANEOUS CAPTIONS

Page 1: Eberhard Grames (German, born 1953)
Boy in a Wrecked Car, Dresden. 1989
Chromogenic color print, approx. 16 × 20 in. (40 × 50.2 cm)
The Museum of Modern Art, New York. Gift of the artist

Frontispiece: Ketaki Sheth (Indian, born 1957)
Shilpa and Sheetal in Their Car, Harrow, Middlesex. 1995
Gelatin silver print, approx. 24 × 20 in. (61 × 50.8 cm)
The Museum of Modern Art, New York. Acquired through the generosity of Ruth Nordenbrook

Pages 4–5: Lucian Bernhard (American, born Germany. 1883–1972)
Poster for Bosch spark plugs (detail). 1914
Lithograph, 17 7/8 × 25 1/4 in. (45.5 × 64.2 cm)
The Museum of Modern Art, New York. Gift of The Lauder Foundation, Leonard and Evelyn Lauder Fund (see page 32)

Pages 6–7: Jacques-Henri Lartigue (French, 1894–1986)
Grand Prix of the Automobile Club of France, Course at Dieppe. 1912, printed 1962
Gelatin silver print, 10 × 13 1/2 in. (25.4 × 34.3 cm)
The Museum of Modern Art, New York. Gift of the artist

Front cover: Photo collage by Amanda Washburn. 2021

Back cover: Edward Ruscha (American, born 1937)
Standard Station. 1966
Screenprint, comp.: 19 5/8 × 36 15/16 in. (49.6 × 93.8 cm); sheet: 25 5/8 × 39 15/16 in. (65.1 × 101.5 cm)
Publisher: Audrey Sabol, Villanova, Pennsylvania
Printer: Art Krebs Screen Studio, Los Angeles
Edition: 50
The Museum of Modern Art, New York. John B. Turner Fund
(see page 82)

Allianz ⦿

The exhibition is made possible by Allianz, MoMA's partner for design and innovation.

Generous funding is provided by Kristen and Andrew Shapiro.

Leadership contributions to the Annual Exhibition Fund, in support of the Museum's collection and collection exhibitions, are generously provided by Jerry I. Speyer and Katherine G. Farley, the Sandra and Tony Tamer Exhibition Fund, The Contemporary Arts Council, Eva and Glenn Dubin, Alice and Tom Tisch, Mimi Haas, the Noel and Harriette Levine Endowment, The David Rockefeller Council, the William Randolph Hearst Endowment Fund, the Marella and Giovanni Agnelli Fund for Exhibitions, Anne Dias, Kathy and Richard S. Fuld, Jr., Kenneth C. Griffin, The International Council of The Museum of Modern Art, Marie-Josée and Henry R. Kravis, and Jo Carole and Ronald S. Lauder.

Major contributions to the Annual Exhibition Fund are provided by The Junior Associates of The Museum of Modern Art, Emily Rauh Pulitzer, Brett and Daniel Sundheim, the Terra Foundation for American Art, Karen and Gary Winnick, and Anna Marie and Robert F. Shapiro.

Published in conjunction with the exhibition *Automania*, at The Museum of Modern Art, New York, July 4, 2021–January 2, 2022

Organized by Juliet Kinchin, Paul Galloway, Collection Specialist, and Andrew Gardner, Curatorial Assistant, Department of Architecture and Design, The Museum of Modern Art, New York

The exhibition is made possible by Allianz, MoMA's partner for design and innovation.

Generous funding is provided by Kristen and Andrew Shapiro.

Leadership contributions to the Annual Exhibition Fund, in support of the Museum's collection and collection exhibitions, are generously provided by Jerry I. Speyer and Katherine G. Farley, the Sandra and Tony Tamer Exhibition Fund, The Contemporary Arts Council, Eva and Glenn Dubin, Alice and Tom Tisch, Mimi Haas, the Noel and Harriette Levine Endowment, The David Rockefeller Council, the William Randolph Hearst Endowment Fund, the Marella and Giovanni Agnelli Fund for Exhibitions, Anne Dias, Kathy and Richard S. Fuld, Jr., Kenneth C. Griffin, The International Council of The Museum of Modern Art, Marie-Josée and Henry R. Kravis, and Jo Carole and Ronald S. Lauder.

Major contributions to the Annual Exhibition Fund are provided by The Junior Associates of The Museum of Modern Art, Emily Rauh Pulitzer, Brett and Daniel Sundheim, the Terra Foundation for American Art, Karen and Gary Winnick, and Anna Marie and Robert F. Shapiro.

Produced by the Department of Publications, The Museum of Modern Art, New York

Hannah Kim, Business and Marketing Director
Don McMahon, Editorial Director
Marc Sapir, Production Director
Curtis R. Scott, Associate Publisher

Edited by Jackie Neudorf
Designed by Amanda Washburn
Production by Matthew Pimm
Color separations by Evergreen Colour Management Ltd., Hong Kong
Printed and bound by DZS Grafik d.o.o., Ljubljana, Slovenia

This book is typeset in Rift and GT America. The paper is 150 gsm Galerie Art Volume

Library of Congress Control Number: 2021933915
ISBN: 978-1-63345-127-8

Published by The Museum of Modern Art
11 West 53 Street
New York, New York 10019-5497
www.moma.org

Distributed in the United States and Canada by Artbook | D.A.P.
75 Broad Street, Suite 630
New York, New York 10004
www.artbook.com

Distributed outside the United States and Canada by Thames & Hudson Ltd
181A High Holborn, London WC1V 7QX
www.thamesandhudson.com

Printed in Slovenia